MW00619553

IMAGES
of America
ALONG VIRGINIA'S
APPALACHIAN TRAIL

Born in 1879, Benton MacKaye is generally considered to be the father of the Appalachian Trail. His proposal for the pathway grew from his observations of an America in the post-World War I era that was becoming rapidly urbanized, machine-driven, and far removed from the positive and reinvigorating aspects of the natural world. He envisioned the trail as a connecting line between a series of permanent, self-sustaining camps in which "cooperation replaces antagonism, trust replaces suspicion, emulation replaces competition." (Courtesy of Appalachian Trail Conference.)

ON THE COVER: In 1939, members of the Roanoke Appalachian Trail Club used a spyglass to gaze across the Great Valley of Virginia and the city of Roanoke from Twelve O'Clock Knob. Across the valley is Fort Lewis Mountain, which the Appalachian Trail passed over from 1934 to 1955. Visible on the far right is a portion of Catawba Mountain where the present-day trail is located. (Courtesy of RATC.)

IMAGES
of America

ALONG VIRGINIA'S APPALACHIAN TRAIL

Leonard M. Adkins and the
Appalachian Trail Conservancy

ARCADIA
PUBLISHING

Copyright © 2009 by Leonard M. Adkins and the Appalachian Trail Conservancy
ISBN 978-0-7385-6630-6

Published by Arcadia Publishing
Charleston, South Carolina

Printed in the United States of America

Library of Congress Control Number: 2009927057

For all general information contact Arcadia Publishing at:
Telephone 843-853-2070
Fax 843-853-0044
E-mail sales@arcadiapublishing.com
For customer service and orders:
Toll-Free 1-888-313-2665

Visit us on the Internet at www.arcadiapublishing.com

*To all Appalachian Trail volunteers, past, present, and future. It is your
dedicated hard work that makes the trail a reality and enables millions
to enjoy, and appreciate, the wonder of the Appalachian woods.*

A portion of the author's royalties from Images of America: *Along Virginia's
Appalachian Trail* is donated to the Appalachian Trail Conservancy.

CONTENTS

ACKNOWLEDGMENTS

It is impossible to acknowledge and thank everyone in a book such as this that takes in close to a century's worth of history. However, to the following, I want to thank you for sharing your photographs and vast wealth of knowledge concerning the Appalachian Trail: Paul M. Clayton, Piedmont Appalachian Trail Hikers; Jackie Holt, Blue Ridge Parkway, U.S. National Park Service; Roger Holnback, Frank Horanzo, David Perry, and Charles Parry, Roanoke Appalachian Trail Club; John Nunn, www.blueridgeskyline.com; Ruth Ball and Norman Sykora, Natural Bridge Appalachian Trail Club; Kadance Muller, Shenandoah National Park, U.S. National Park Service; Susan Gail Arey, Tidewater Appalachian Trail Club; Fran Leckie, Jack Williams, Brian Wakeman, and Henry Harman, Old Dominion Appalachian Trail Club; April Miller, Potomac Appalachian Trail Club; and Brian King and Laurie Potteiger, Appalachian Trail Conservancy.

The biggest thank you goes to Laurie Messick Adkins, also known as The Umbrella Lady, my companion for more than 16,000 miles of long-distance hiking.

KEY TO ABBREVIATIONS USED THROUGHOUT TEXT

AT—Appalachian Trail
ATC—Appalachian Trail Conference (Appalachian Trail Conservancy)
BRP—Blue Ridge Parkway, U.S. National Park Service
CCC—Civilian Conservation Corps
NBATC—Natural Bridge Appalachian Trail Club
ODATC—Old Dominion Appalachian Trail Club
PATC—Potomac Appalachian Trail Club
PATH—Piedmont Appalachian Trail Hikers
RATC—Roanoke Appalachian Trail Club
SNP—Shenandoah National Park, U.S. National Park Service
TATC—Tidewater Appalachian Trail Club

INTRODUCTION

When people learn that I have hiked the entire Appalachian Trail five times, I'm often asked what I consider to be the pathway's most beautiful part. Always my answer is that the trail's most beautiful aspect is the volunteers who have given millions of hours of their time throughout the decades.

Speaking from experience, building and maintaining the trail is not easy. Work can begin only after volunteers have lugged picks, shovels, chainsaws, and other heavy tools multiple miles uphill. Many times the work involves quarrying half-ton boulders, digging out Volkswagen Beetle-sized root-balls, eradicating yards of entangling greenbrier and poison ivy vines, and sawing hundreds of pounds of downed tree trunks and limbs. Power tools are not permitted in places designated as wilderness areas, thus all the sawing must be done by hand in those areas. There have been trips where the ground conditions were so tough that, despite the best efforts of 20 or more volunteers, less than 100 yards of trail were built during a Saturday and Sunday work hike. Yet, regardless of this, more than 2,000 miles of the Appalachian Trail exist! It is astounding that people take whatever bit of leisure time they have in their busy lives and volunteer to do hard manual labor just so that you and I can take a walk in the woods.

It was volunteers who made the Appalachian Trail possible from its very beginnings.

Benton MacKaye proposed a trail along the crest of the Appalachian Mountains in the October 1921 issue of the *Journal of American Institute of Architects*. Within two years, volunteers in New York built the first miles of trail constructed specifically for the Appalachian Trail. Two years after that, the Appalachian Trail Conference (the name changed to Appalachian Trail Conservancy in 2005) was formed and managed by volunteers. By 1927, Potomac Appalachian Trail Club volunteers were hard at work building the AT in Virginia.

MacKaye was the trail's visionary, but it was Myron Avery who is most often credited with making the trail a reality. While working a full-time job, he served as Potomac Appalachian Trail Club's president from 1927 to 1940, Appalachian Trail Conference chairman from 1931 to 1952, Maine Appalachian Trail Club's trails supervisor from 1935 to 1949, and the latter organization's president from 1949 to 1952. All of these were volunteer positions. Using the Potomac Appalachian Trail Club as a model, Avery reached out to other hikers and helped them form additional Appalachian Trail maintaining clubs, such as the Natural Bridge Appalachian Trail Club and Roanoke Appalachian Trail Club, in the central and southern parts of Virginia. Because he was on the trail nearly every weekend throughout those years—scouting a route, leading a work hike to build trail, or measuring a newly constructed section of the pathway—he became the first person to walk the Appalachian Trail's full length.

The two most avid proponents of the Appalachian Trail had different visions for the pathway. MacKaye iterated it was a means for regional planning, a way to establish workers' communities along its route. His hope was that those communities would foster an America that would question the expansion of its cities and the increasing enslavement to mechanized work and

commercialism. Avery saw the trail as merely a footpath, a way through the mountains for those who enjoyed outdoor recreation.

Construction of Skyline Drive drove the final wedge between the two. Avery accepted the venture, seeing it as a means of acquiring federal support for the Appalachian Trail, thereby aiding its completion. MacKaye despised the notion of skyline drives. He felt they were not only an intrusion, but were, in reality, conspiracies by businessmen to profit off the wilderness. This difference was so great that MacKaye more or less turned his back on the Appalachian Trail, putting his efforts into the Wilderness Society, which he helped form in 1935.

MacKaye and Avery may have been having their differences, but the volunteers kept cooperating with each other and the Appalachian Trail was completed from Georgia to Maine in 1937. In 1938, a major hurricane swept through the Northeast, killing 700 people, leaving 60,000 homeless, and destroying so many miles of trail that volunteers were overwhelmed. Soon afterward, construction of the Blue Ridge Parkway displaced more than 100 miles of the Appalachian Trail. With Americans' attentions turned toward World War II, more miles fell into disrepair and many people began to doubt that the Appalachian Trail would ever again be one continuous route.

On April 4, 1948, Earl V. Shaffer set out in Georgia to hike the entire Appalachian Trail, not to establish any records, but to enjoy his time in the mountains and help put his World War II memories in perspective. He completed the trail's first thru-hike (a trek of the trail's full length in one continuous journey) atop Katahdin in Maine on August 5. Three years later, Gene Espey duplicated the feat. Two years after that, Emma "Grandma" Gatewood became the first woman to thru-hike the trail alone.

The exploits of these people revived interest in the trail, and it was from this time onward that volunteers, realizing that the trail was being affected by the modern world, began to do more than just work on the pathway.

Mining, timbering, ski resorts, housing projects, communication and utility towers and lines, and new roadways were encroaching on the trail and detracting from its wilderness experience. In response, trail supporters pressed to get the National Trails System Act (sometimes referred to as the National Scenic Trails Act) passed in 1968. The act designated the Appalachian Trail and the Pacific Crest Trail as the country's first two national scenic trails and allocated monies to purchase land. Further lobbying resulted in the 1978 Appalachian Trail Act that allocated additional funds. It certainly must be acknowledged that much of the land for the Appalachian Trail was sold unwillingly, but the many benefits that accrued cannot be denied. Millions of Appalachian Trail visitors have enjoyed these lands that—based upon what has happened to other eastern mountain areas—might have been turned into housing developments or resorts if they had remained in private hands.

Through the years, volunteers have taken on more and more tasks. Corridor stewards walk the trail's steep, rugged, and irregular boundary to check for encroachments such as prohibited hunting, timber theft, trash dumping, illegal construction of roadways or buildings, as well as ATV, equestrian, and mountain bike use and damage. Natural heritage monitors aid the Appalachian Trail Conservancy and national park service in overseeing the welfare of rare, threatened, and endangered plants. Others labor at keeping invasive species from spreading across the land. Some work with scientists to learn about the impact of air pollution, pest insects, diseases, and water quality on the Appalachian Trail's natural world. Sometimes the effort to protect the trail rises as a grassroots effort. A perfect example is when, after receiving letters of protest, the Virginia Department of Transportation canceled plans to build a four-lane highway across the Appalachian Trail that would have split the Mount Rogers National Recreation Area in two and turned Comer's Creek into a concrete culvert.

Volunteers spend hours in classrooms learning wilderness first aid and the best ways to safely operate chain saws. Local clubs need to have people with sign making skills, shelter construction experience, and tool maintenance knowledge. There is often the need for legal expertise: the Roanoke Appalachian Trail Club spent hundreds of hours trying to find an alternative to a proposed power line that would have paralleled the Appalachian Trail for many miles. The

club's members' efforts paid off, and the power line only passes over the Appalachian Trail at an interstate highway crossing.

The local maintaining clubs' board members work with local, state, and federal units, develop hikes and other outings for the general public, provide outreach and public speakers to schools and organizations, and occasionally serve as media spokespersons, as well as help coordinate law enforcement efforts in an emergency.

The increase in trail use (the Appalachian Trail Conservancy estimates 4 million people visit the Appalachian Trail annually) has led to trail construction and rehabilitation projects beyond the capabilities of the local clubs. In Virginia, the Konnarock Crew, in which people volunteer for five days to do intensive trail work with knowledgeable trail bosses, has created miles of well-built pathway that will not need any other work for decades. (There are other such groups along the entire trail.)

Often the protection of the Appalachian Trail comes down to donated dollars. Like the Blue Ridge Parkway's need to protect its viewsheds, the Appalachian Trail must also safeguard its outer edges. Since 1982, ATC and affiliated organizations have purchased, with almost entirely private contributions, tens of thousands of acres of land adjacent to the trail.

In each of the last several years, in excess of 6,000 volunteers have provided more than 200,000 hours of their time for the Appalachian Trail—maybe it's time for you to get in on the fun.

Spend some energetic, but rewarding days filled with the camaraderie of the trail—become a member of the Appalachian Trail Conservancy and one of the maintaining clubs and join them on a work hike to build, rebuild, or maintain a section of the Appalachian Trail:

Appalachian Trail Conservancy
P. O. Box 807
Harpers Ferry, WV 25425-0807
304-535-6331
www.appalachiantrail.org

Maintains 55.9 miles from Damascus, Washington County, to South Fork of the Holston River (VA-670), Smyth County:

Mount Rogers Appalachian Trail Club
P.O. Box 2218
Abingdon, VA 24212
www.mratc.org

Maintains 64 miles from South Fork of the Holston River (VA-670), Smyth County, to I-77, Bland County:

Piedmont Appalachian Trail Hikers
P. O. Box 4423
Greensboro, NC 27404
www.path-at.org

Maintains 27.3 miles from I-77, Bland County, to VA-611, Bland County, and from the New River (U.S. 460), Giles County, to Pine Swamp Branch Shelter near VA-635, Giles County:

Outing Club of Virginia Tech
P. O. Box 538
Blacksburg, VA 24063
www.outdoor.org.vt.edu

Maintains about 121.2 miles from VA-611, Bland County, to the New River (U.S. 460), Giles County, and from Pine Swamp Branch Shelter near VA-635, Giles County, to Black Horse Gap on the Blue Ridge Parkway, Botetourt County:

Roanoke Appalachian Trail Club
P. O. Box 12282
Roanoke, VA 24024
www.ratc.org

Maintains 90.6 miles from Black Horse Gap on the Blue Ridge Parkway, Botetourt County, to the Tye River (VA-56), Nelson County:

Natural Bridge Appalachian Trail Club
P. O. Box 3012
Lynchburg, VA 24503
www.nbatc.org

Maintains 10.5 miles from the Tye River (VA-56), Nelson County, to Reeds Gap (VA-664), Nelson County:

Tidewater Appalachian Trail Club
P. O. Box 8246
Norfolk, VA 23503
www.tidewaterc.org

Maintains 19.1 miles from Reeds Gap (VA-664), Nelson County, to Rockfish Gap (I-64), Nelson County:

Old Dominion Appalachian Trail Club
P. O. Box 25383
Richmond, VA 23260
www.odatc.org

Maintains 239.8 miles from Rockfish Gap (I-64), Nelson County, through Shenandoah National Park, Northern Virginia, West Virginia, and Maryland to Pine Grove Furnace State Park in Pennsylvania:

Potomac Appalachian Trail Club
118 Park Street, S.E.
Vienna, VA 22180
www.potomacappalachian.org

Note: When putting this book together, it became obvious that with the many route changes the AT has experienced, it would be impossible to arrange the photographs in a merely chronological or geographical order. Therefore, I have used a combination of the two, with older routes coming before the newer ones and the photographs arranged in chronological order along each route.

One

THE OLDER ROUTE IN SOUTHERN VIRGINIA

Coming from Tennessee and other southern states, the Appalachian Trail enters Virginia and runs along the main street of Damascus, known as the "Friendliest Town on the Trail." North of Damascus, the Appalachian Trail in southern Virginia has been relocated so many times and in so many places that it will be impossible to cover all of those changes in this book. Therefore, only the most significant of relocations are included.

The original route out of Damascus followed the crest of Iron Mountain, about 5 miles west of Mount Rogers. North of Comers Creek, the trail continued eastward, instead of veering off to the west as the present day trail does. This older route provided a number of outstanding views, including 4,035-foot Comers Rock, 3,823-foot Jones Knob, and 3,040-foot Farmer Mountain. The one-third of a mile side trail to Perkins Knob led to a vista of the sheer cliffs in the New River Canyon. (All of these high points are within the Jefferson National Forest and are still accessible via foot travel.) Near Farmer Mountain, the trail turned southward along the New River, crossing close to Fries via the Dixon Ferry (the charge was 5¢ in 1932), and passing through Galax, whose world-famous fiddlers' convention began in 1935. Beyond the town, the trail crossed back into North Carolina for about 8 miles.

Returning to Virginia, the Appalachian Trail followed the main crest of the Blue Ridge Mountains and skirted Fishers Peak (now the site of the Blue Ridge Parkway's Blue Ridge Music Center). Crossing U.S. 121 (now U.S. 52) at Fancy Gap, the trail made the extremely steep ascent and descent of the Pinnacles of Dan and went close to or by Mabry Mill, Rock Castle Gorge, and Rocky Knob. These places are now familiar to travelers on the parkway, whose construction began to obliterate the trail in the early 1940s and necessitated the major relocation that has the trail leaving the Blue Ridge Mountains and turning west across the Great Valley of Virginia and into the Allegheny Mountains.

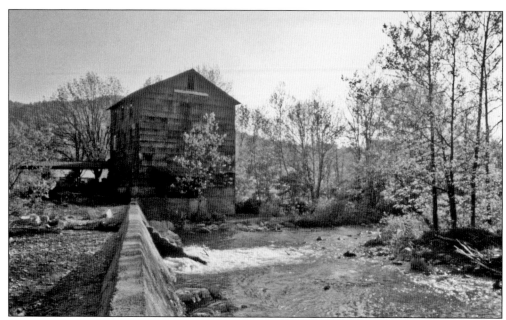

Damascus had its beginnings in 1821, when settlers arrived to establish Mock's Mill. In 1886, John D. Imboden began extracting the area's timber and mineral wealth. Because of the abundance of natural resources, he named the area for Damascus, the ancient capital of Syria. A mill on the south bank of Laurel Creek (above), photographed in 1976, was one of the first businesses. It was recently renovated into a restaurant and inn but was closed for business as this book went to press. Operated through the generosity of the Damascus First United Methodist Church, "The Place" (below) provides hikers with bunk space, showers, kitchen facilities, and picnic tables. Opened in 1976, when this photograph was taken, the hostel has given tens of thousands of weary Appalachian Trail hikers a temporary home in which to rest and relax. (Both photographs courtesy of Susan Gail Arey.)

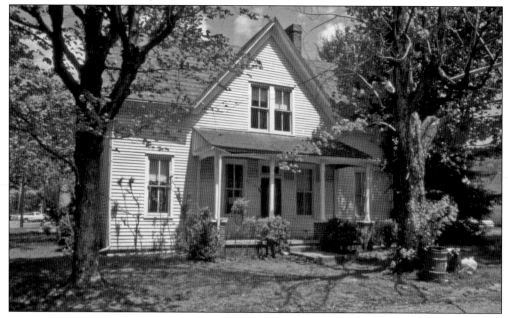

Alice and Charles Trivett, who knew little about the Appalachian Trail until they read a book about it in 1975, are not members of the Damascus First United Methodist Church, yet they have been looking after "The Place," and the hikers that stay in the hostel, since it opened in 1976, the year of this photograph. (Courtesy of Susan Gail Arey.)

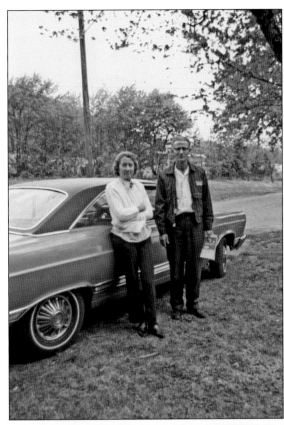

In 1987, Dan "Wingfoot" Bruce (with his back to the camera) conceived of Trail Days as a way to celebrate the 50th anniversary of the Appalachian Trail's completion. Gene Espy (with backpack on), who was the second person to thru-hike the Appalachian Trail (in 1951), conversed with Bruce on the lawn of "The Place." (Courtesy of ATC.)

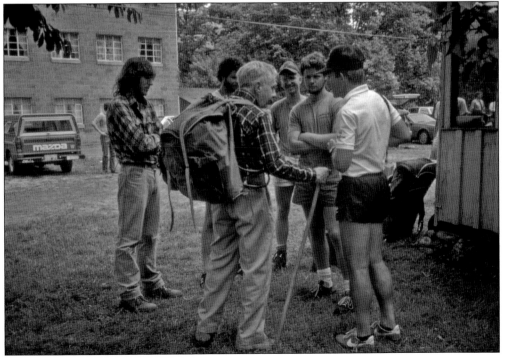

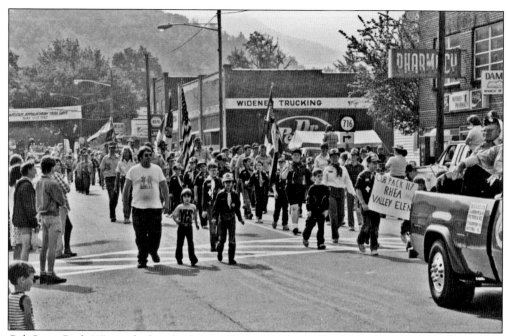

Cub Scout Pack 117 marched in the first Trail Days parade in 1987. The celebration is held annually in May and attracts thousands of hikers, locals, and visitors for a series of events focusing on the trail, including hiker talent contests, backpacking equipment demonstrations, and multimedia presentations. (Courtesy of ATC.)

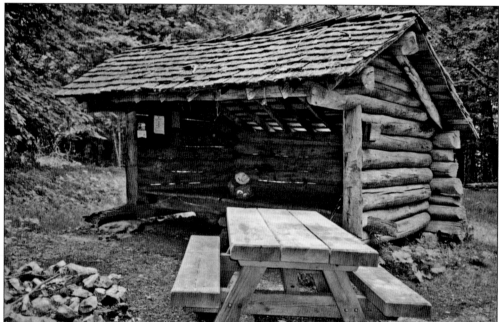

There were no shelters along Iron Mountain in the Appalachian Trail's early days, and this spot was simply known as Cherry Tree Campsite. The Cherry Tree Shelter, built in the mid-1900s, is a typical Appalachian Trail shelter with three walls and an open front. ATC's shelter construction guidelines calculate capacity at one person per 15 square feet. (Courtesy of Susan Gail Arey.)

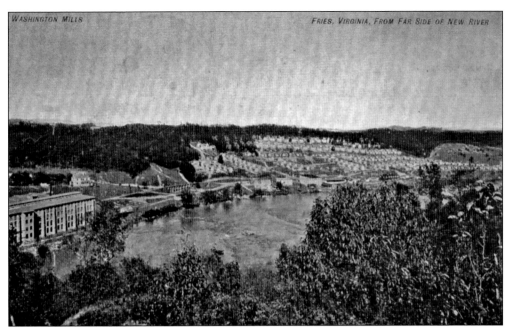

The town of Fries (pronounced "freeze") along the New River was a short distance off of the Appalachian Trail and was used as a resupply stop by Earl Shaffer on his 1948 thru-hike. The Washington Cotton Mills, seen in this 1910 postcard, was the town's primary employer and operated from 1903 to 1989. (Courtesy of St. Louis Postcard Company.)

For its first few decades, the Appalachian Trail was on roadways from Fries to Galax, a distance of almost 6 miles. Coming from Fries on Fries Road (in the background) the trail crossed U.S. 58 (in the foreground) and went through Galax on West Center Road, passing by the Hotel Bluemont. (Courtesy of Susan Gail Arey.)

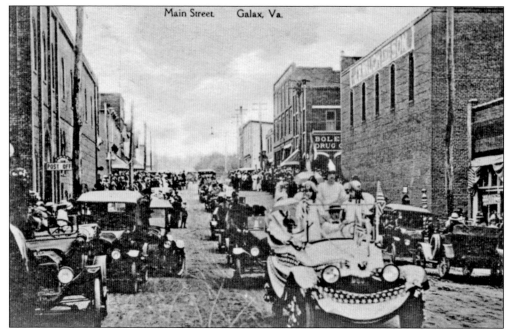

Roads in Galax were paved in 1920, so this rare postcard (which has sold for $75 at auctions) shows a parade that must have taken place prior to that year. The postcard was produced by the Bolen Drug Company (seen on the right side of the street), one of the first businesses to be established after the town was laid out in 1903. (Courtesy of Bolen Drug Company.)

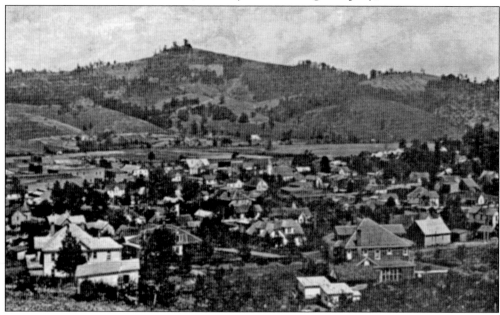

This postcard's publisher is identified as the Auburn Post Card Manufacturing Company. Its name was changed to the Auburn Greeting Company in 1929, so the photograph would have been taken prior to that year. The town's original name was Cairo, then Bonaparte, and finally Galax in 1905. Earl Shaffer spent a night in a boardinghouse during his 1948 thru-hike. (Courtesy of Auburn Post Card Manufacturing Company.)

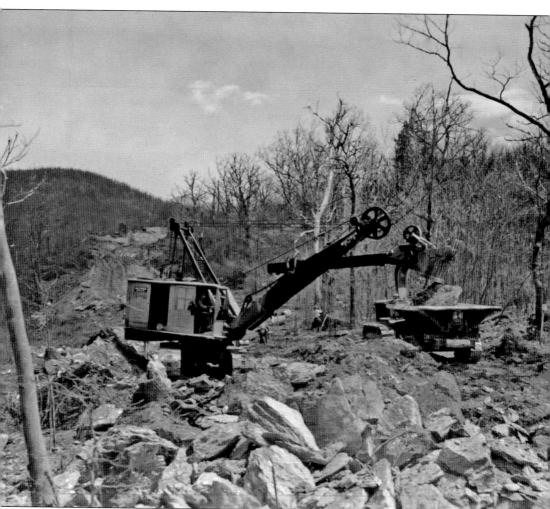

In 1933, Pres. Franklin Roosevelt made an inspection tour of a Civilian Conservation Corps camp in northern Virginia and was well pleased with the progress and potential of the Skyline Drive. Prodded by local politicians (who realized its economic benefits) in Virginia, North Carolina, and Tennessee, Roosevelt approved the Blue Ridge Parkway and development began on September 11, 1935. The volunteers that built the Appalachian Trail primarily employed hand tools. In contrast, contractors hired by the federal government used heavy equipment, such as this bucket excavator photographed by D. C. Ochsner in 1938. Private contractors, who had to win bids, did most of the heavy construction, while members of the Civilian Conservation Corps did the landscaping and structure building. The parkway was often built directly on top of what had been the route of the Appalachian Trail. The scenic highway was finally completed with the construction of the Linn Cove Viaduct on the side of Grandfather Mountain in North Carolina in 1983. (Courtesy of BRP.)

Designers of the parkway took care to ensure that it blended in as much as possible with the natural scenery. Therefore, culverts, like this one photographed in 1938, were constructed of native stone, often obtained from road cuts nearby. Parkway culverts do not employ corrugated piping, but allow streams to flow on their own bed, thereby providing a natural passage for fish. (Courtesy of BRP.)

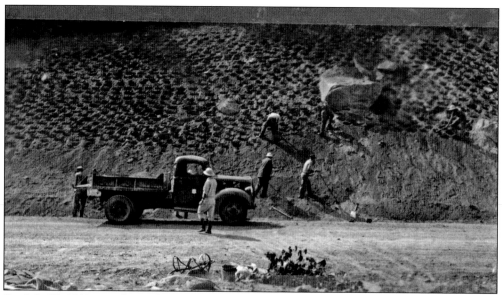

On July 27, 1943, members of a conscientious objectors work program took part in an erosion control project by digging holes for root plantings on the upper part of a parkway slope and by grading the lower portion to prepare it to be planted with grass seeds. (Courtesy of BRP.)

18

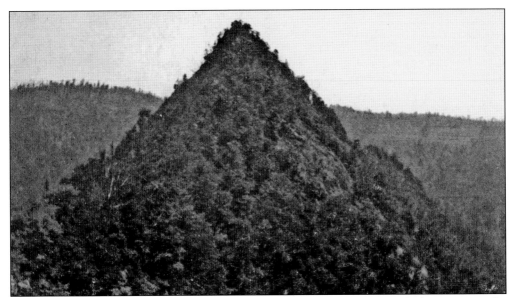

When the Appalachian Trail was being scouted in the 1930s, trailblazers marked a route over the Pinnacles of Dan as a joke, thinking it so tough that it would be rejected. Myron Avery thought it so spectacular that he made it the official route, although, at first, the summit was reached by a one-third of a mile side trail. The hike immediately became a favorite of many hikers. (Courtesy of ATC.)

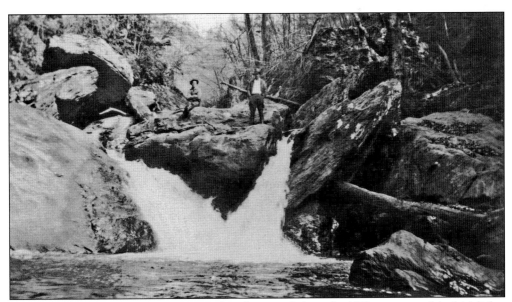

The Little Falls of the Dan River, seen in this photograph from the 1930s, was one of the highlights of the Appalachian Trail as it worked its way along the stream toward the Pinnacles of Dan. The pathway also went by the Big Falls of the Dan River. (Courtesy of ATC.)

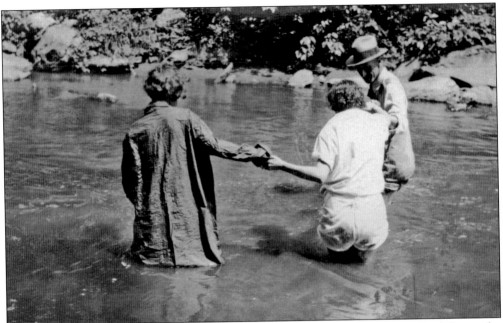

On July 2, 1933, members of the Natural Bridge Appalachian Trail Club took a hike to the Pinnacles of Dan, which involved fording the Dan River at the mouth of Round Meadow Creek. The river curls around the pinnacles, making it visible on three sides from the summit. (Courtesy of NBATC.)

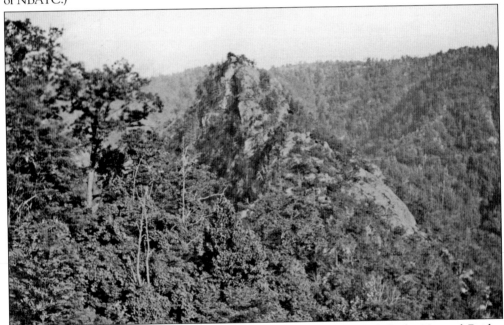

The Pinnacles of Dan were photographed during the July 2, 1933, hike by Natural Bridge Appalachian Trail Club members. Of the ascent, Earl Schaffer, in *Walking with Spring*, stated, "It was rock work pure and simple, with a precipice on either side. Any pack at all, much more than the forty pounds I was carrying, was a handicap and even a hazard. The view from topside was astounding." (Courtesy of NBATC.)

During a hike to the Pinnacles of Dan in September 1940, members of Roanoke Appalachian Trail Club (right) paused to look at the Townes Dam, built in the 1930s. It forced the Appalachian Trail to make a more direct route eastward instead of meandering along the western bank of the Dan River. There is no doubt that the Pinnacles of Dan was the most formidable terrain of the entire Appalachian Trail in Virginia. Coming down from the summit (bottom) in September 1940, Roanoke Appalachian Trail Club members (from top to bottom) Vivian Dick and Dick Walrond used a rope to help with the descent. Wee Wee Frantz appears to be looking to see if the rope injured her hands. Describing the descent, Earl Schaffer said, "It was necessary to go backward most of the time, along narrow ledges and clutching bushes to keep from falling." (Both photographs courtesy of RATC.)

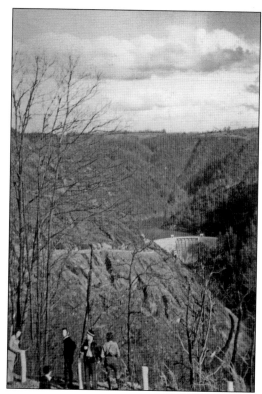

A few miles north of the Pinnacles of Dan, an eight-tenths of a mile side trail led from the Appalachian Trail to Lovers' Leap and the Lovers' Leap Tavern that had a gasoline filling station, served meals, and had three small cabins with accommodations for six. The viewpoint, now accessible along U.S. 58 about 10 miles west of Stuart, is on the eastern escarpment of the Blue Ridge Mountains and shows the land dropping (above) from the mountainous heights to the flat lands of the Virginia piedmont (below). There are dozens of places called Lovers' Leap around the world. All seem to have somewhat the same legend behind them—two people from disparate backgrounds fell in love and, when prohibited from marrying, jumped to their deaths so that they could be together for all eternity. (Both photographs courtesy of Susan Gail Arey.)

The Appalachian Trail did not go by Mabry Mill, but due to the condition of the pathway from lack of maintenance during World War II and the disturbance to the trail by the construction of the Blue Ridge Parkway, Earl Shaffer found himself walking by the mill on his 1948 thru-hike. As shown here, reconstruction of the mill by the park service began in the 1940s. Edwin Boston Mabry operated the mill variously, or in combination, as a gristmill, sawmill, wheelwright shop, and blacksmith shop from about 1905 to 1935. A system of belts inside the building transferred power to where it was needed. The 1869 cabin in the background was moved to this site for demonstration purposes in the 1940s to replace Mabry's 1915 white frame house that had been destroyed a few years earlier. Restored by the park service and opened to the public in 1950, the mill and the constructed reflecting pond in front of it have become what many believe to be the parkway's most photographed scene. (Courtesy of BRP.)

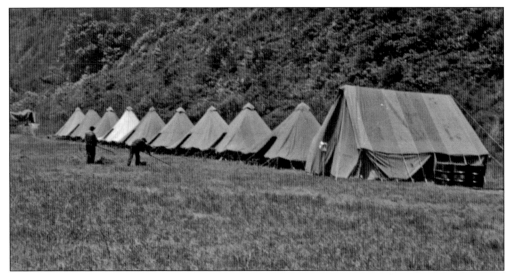

The Rock Castle Gorge Civilian Conservation Corps camp consisted of only a few tents as of May 23, 1938. Later, the "boys" of the camp, located in the gorge close to present-day VA-605, built their own wooden barracks, mess hall, and washhouse. They also constructed picnic facilities, cabins, comfort stations, and miles of trails in the Rock Castle and Rocky Knob areas. (Courtesy of BRP.)

Rocky Knob Shelter was constructed by the Civilian Conservation Corps in 1937. The Appalachian Trail originally went over the summit but was removed a short time later. In 1938, when this photograph was taken, Mountain Club of Virginia members returned the trail to the knob. Earl Shaffer spent the night on his first thru-hike here and said "the temperature must have been around freezing." (Courtesy of BRP.)

Two

THE NEWER ROUTE IN SOUTHERN VIRGINIA

Construction of the Blue Ridge Parkway in the 1930s and 1940s displaced so much of the Appalachian Trail that it prompted trail supporters to start scouting a major change in the route. After years of work, the relocation that brought the trail into the Allegheny Mountains and onto lands recently acquired by the Jefferson National Forest was opened in 1955.

At first, the Appalachian Trail continued on Iron Mountain, but in the early 1970s it was moved eastward over Whitetop Mountain to skirt Mount Rogers. For a brief time, the trail was relocated onto Rogers' summit, but was soon moved east of the mountain. North of Mount Rogers, the trail of today swings westward, going by reminders of logging activities in the early part of the 20th century and manganese mining during World War II. Crossing the Great Valley of Virginia, the Appalachian Trail goes over Big Walker Mountain (whose ridgeline the trail followed for many miles prior to the 1980s) and attains Garden Mountain to overlook Burke's Garden before descending into Lickskillet Hollow.

Like their predecessors of a generation ago who worked hard to relocate the Appalachian Trail, so too have many members of the Roanoke Appalachian Trail Club toiled to move the trail to optimal locations. The club has relocated the majority of its more than 120 miles since the late 1970s, much of it onto land purchased through the U.S. National Park Service acquisition program. The new pathways have taken the trail off roads and into more scenic areas and have been well constructed with switchbacks to reduce erosion problems and eliminate steep ascents.

From Lickskillet Hollow, the Appalachian Trail traverses Pearis Mountain and crosses the New River to enter central Virginia.

North of Damascus, the Appalachian Trail crosses, as it did when this 1976 photograph was taken, the open natural bald on the side of Whitetop Mountain. The trail descends just a few hundred feet before it reaches the summit covered by Fraser fir and red spruce, located at its natural southern limit. (Courtesy of Susan Gail Arey.)

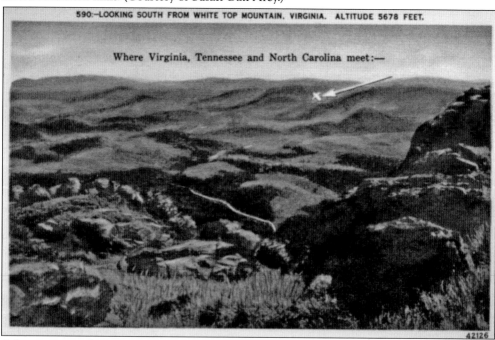

A linen postcard, c. 1930–1945, depicts the view from Whitetop Mountain and points out where Virginia, North Carolina, and Tennessee meet. The postcard states that the mountain, the second highest point in the state, is 5,678 feet above sea level, but according to the 2003 *Appalachian Trail Guide to Southwest Virginia*, the elevation is 5,560 feet. (Courtesy of Asheville Post Card Company.)

26

In the 1930s, members of Roanoke Appalachian Trail Club climbed an observation tower on the summit of 5,729-foot Mount Rogers, the state's highest point. At the time of this outing, the forest service trimmed the trees to allow for a better view. The trees are no longer cut and the tower was dismantled in the mid-1900s. (Courtesy of RATC.)

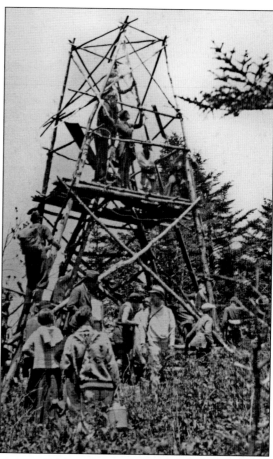

Susan Gail Arey posed on Mount Rogers during her 1976 thru-hike, when the trail went over the summit. Most of the Fraser fir trees, which are at their natural northern limit here, have succumbed to the effects of insect infestation. The mountain is named for William Barton Rogers, designated as Virginia's first state geologist in 1835. (Courtesy of Susan Gail Arey.)

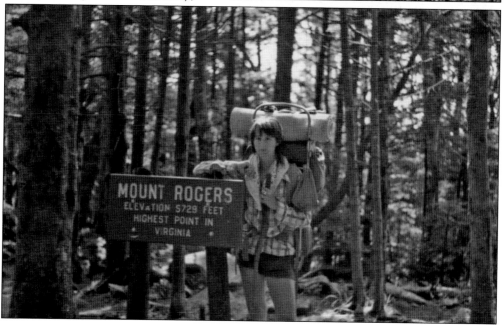

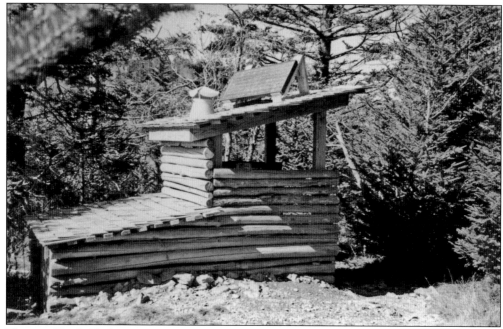

Thomas Knob Shelter's composting privy was built by volunteers from the Mount Rogers Appalachian Trail Club, which was established in 1960. The solar-powered fan draws air into the compost, helping with the decomposition process and the management of liquid wastes. (Courtesy of ATC; photograph by Laurie Potteiger.)

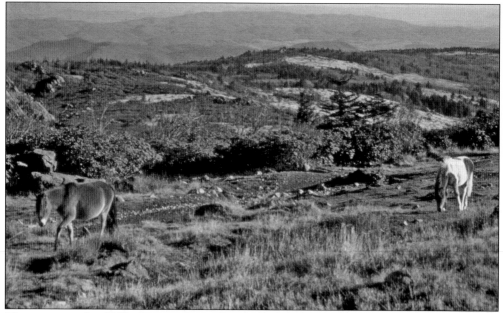

The ponies in this 1980 photograph may be some of the originals placed in the Mount Rogers National Recreation Area in the mid-1970s. This breed has the ability to graze year-round by withstanding the highlands' cold temperatures; as a result, the animals were introduced to keep the meadows from becoming overgrown. There is now concern that the ponies may be doing damage to the fragile environment. (Courtesy of Leonard M. Adkins.)

The Appalachian Trail's protected corridor helps preserve habitat for rare, threatened, or endangered plants, such as the Gray's Lily. This plant is rarely found anywhere in Virginia except in the high, open meadows of the Mount Rogers National Recreation Area. (Courtesy of Joe Cook; photograph by Joe and Monica Cook.)

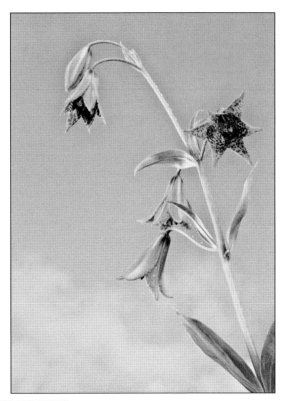

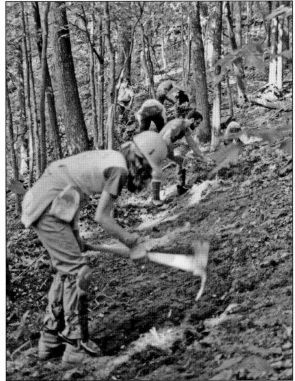

Formed in 1983, the Appalachian Trail Conservancy's Konnarock Crew's volunteers spend five days or more each hiking season providing aid with trail projects that are too extensive, strenuous, or beyond the expertise of the local maintaining clubs. After determining where the trail would be located, crew and club members began to dig a section of the footpath in the mid-1980s. (Courtesy of ATC.)

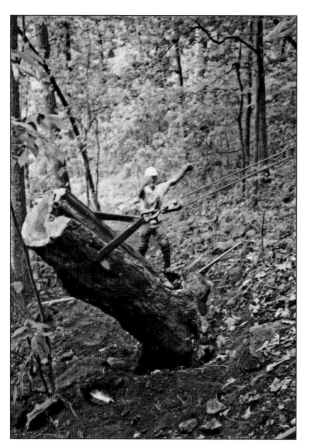

Under the supervision of a trained trail boss in the mid-1980s, volunteers used a come-along to extract a heavy tree trunk and its root-ball from the middle of the trail that could not be removed with conventional digging tools. (Courtesy of ATC; photograph by John Killam.)

Sometimes there are no specific tools for a particular task and pure muscle power must be used, such as the time in the mid-1980s when Konnarock crew members moved a huge rock from the open meadows of the Mount Rogers National Recreation Area to be used in trail construction. (Courtesy of ATC.)

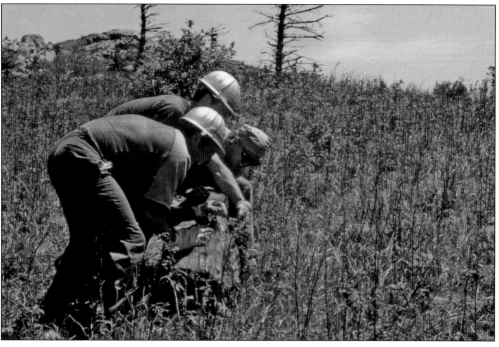

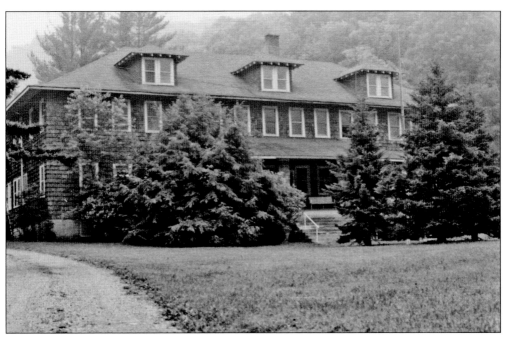

The crew received its name from its first headquarters, the former Konnarock Training School, built in 1924 by the Lutheran church as a girls' boarding school. Constructed with native hardwoods and sided with chestnut shakes, the school educated rural Virginia girls for more than two decades. This photograph by Gordon Burgess was taken on June 28, 1984. (Courtesy of PATH.)

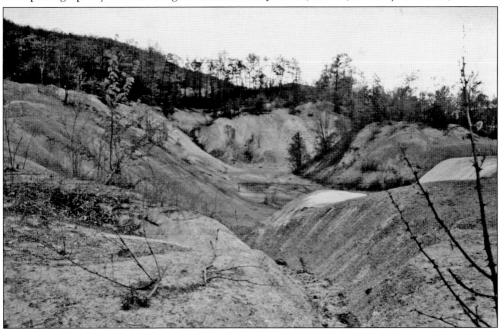

Just before leaving the Mount Rogers National Recreation Area, the Appalachian Trail passes through lands that were strip-mined for manganese during World War II. Although some vegetation has grown up since this 1976 photograph, the ground still has white-, magenta-, and purple-stained soils in some places. (Courtesy of Susan Gail Arey.)

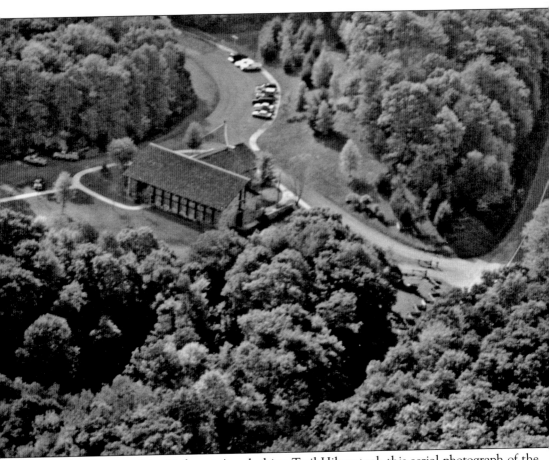

Gordon Burgess of the Piedmont Appalachian Trail Hikers took this aerial photograph of the Mount Rogers National Recreation Area's headquarters. The Appalachian Trail goes through the parking lot, down the driveway, and across VA-16. When the recreation area was established in 1966, some people saw it as a way to develop the region and proposed that a major ski resort, complete with multiple runs, lifts, and condominiums be constructed in the high country. Those who prefer more of a natural landscape prevailed. The natural area's 158,000 acres have more than 400 miles of trail, some which are old logging roads or railroad grades. Some of the trails are also open to mountain bikers and equestrians. Below summits covered with spruce and fir are thousands of acres of open meadows dotted by clusters of rocky outcrops. With far-off vistas, the region reminds many of the Continental Divide in Montana and Wyoming rather than Virginia. The herds of wild ponies and grazing cattle add to the feeling of being in the American West. (Courtesy of PATH.)

Much of the Appalachian Trail is located upon land that was once private property. Edna Shupe (right), photographed with Lurleen Foglesong on September 9, 1981, sold the land close to the Settlers Museum that the AT passes through near Groseclose. Both women attended the 1894 Lindamood School that has been restored by the museum. (Courtesy of PATH; photograph by Gordon Burgess.)

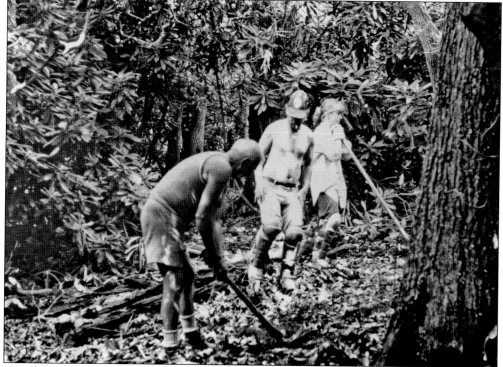

Sometime in the 1980s, Piedmont Appalachian Trail Hikers volunteer Henry Ford (others are unidentified) removed a root to make the Appalachian Trail north of the Mount Rogers National Recreation Area smoother. Piedmont Appalachian Trail Hikers was formed in 1965 and most members live in the Charlotte/Raleigh, North Carolina area, yet are willing to drive many miles to maintain their 64 miles of the Appalachian Trail. (Courtesy of ATC.)

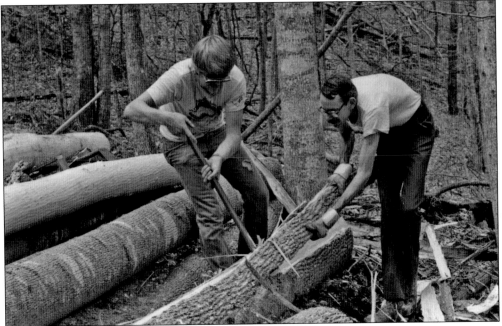

In 1984, ATC regional representative Mike Dawson (left) trained Piedmont Appalachian Trail Hikers volunteer Bill Sims in the proper and most efficient way to peel bark off one of the logs that was used in the Davis Path Shelter. The bark traps water, and the log would rot much sooner if the bark was not removed. (Courtesy of ATC.)

Gordon Burgess photographed the Davis Path Shelter soon after it was completed in 1984. The structure is close to an early pathway over the mountains that went from Davis Valley to Bear Creek via Gullion Mountain. Irish immigrant James Davis made his home here in 1748. (Courtesy of PATH.)

After crossing I-81, the Appalachian Trail passes through Crawfish Valley, close to where James Mozer lived; a plaque on a large tree three-tenths of a mile from the trail marks his homesite. Gordon Burgess, who took the photograph in 1984, learned that Mozer kept a complete stock of "yarbs," or medicinal herbs, that he collected. (Courtesy of PATH.)

Gordon Burgess (left), James Mozer, and an unidentified Piedmont Appalachian Trail Hikers member posed at Mozer's farm in 1985. Burgess was about 5 feet, 6 inches tall, so Mozer must have been barely 5 feet. His old homesite is identified as a good campsite in the official Appalachian Trail guides. (Courtesy of PATH.)

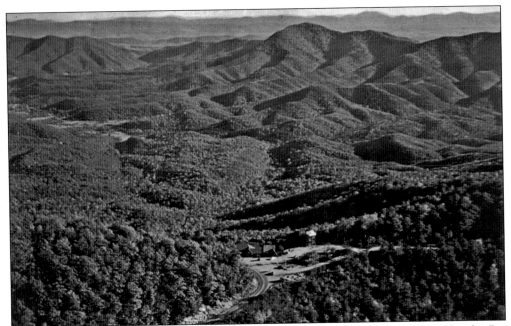

The Appalachian Trail followed Big Walker Mountain from 1955 to 1980, passing by the Big Walker Lookout Tower. The roadside attraction has been in operation since 1947, providing hikers and tourists with, as the postcard says, "One of the most beautiful scenes of panoramic splendor in the southern Appalachians." (Courtesy of Greear Studio, Marion.)

A holdover from the days of the mid-1900s roadside tourist attractions, the café at the Big Walker Lookout Country Store has helped nourish and slake the thirst of many travelers for many decades. The store pictured here replaced the old one that burned in 2003. (Courtesy of Susan Gail Arey.)

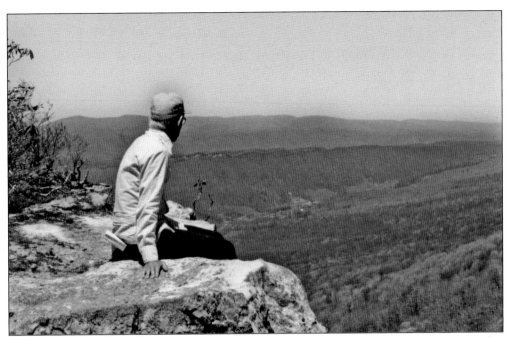

In 1986, Gordon Burgess overlooked Beartown Wilderness and Burkes Garden from atop Garden Mountain, where the Appalachian Trail was moved to from Big Walker Mountain in 1980. The wilderness contains what is believed to be the largest sphagnum bog in Virginia. There are different types of bogs, and the differences are subtle, depending on location, origin, predominant plants, and water source. (Courtesy of PATH; photograph by Gordon Burgess.)

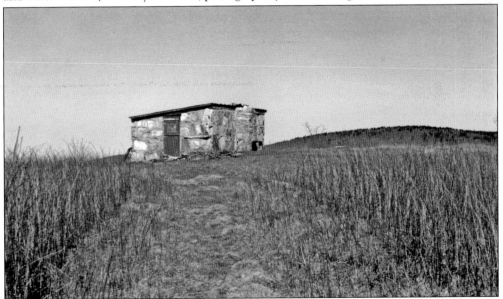

The Chestnut Knob Shelter on Garden Mountain was once a fire warden's cabin. Its privy has a grandstand view of the expanse of Burke's Garden, more than 1,300 feet below. With the circular ridgeline of Garden Mountain nearly surrounding this indentation in the landscape, it is easy to see why some people refer to it as God's thumbprint. This photograph by Gordon Burgess was taken in the 1980s. (Courtesy of PATH.)

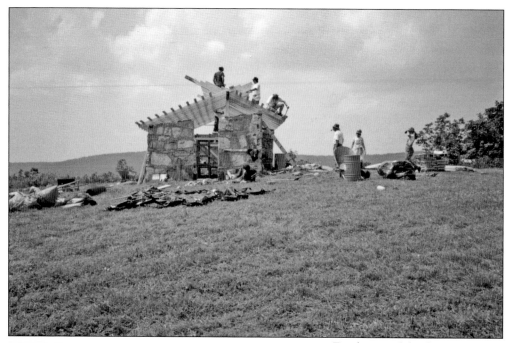

Employees of the forest service and volunteers from Piedmont Appalachian Trail Hikers and the Konnarock Crew rehabilitated the Chestnut Knob Shelter in 1994. The remodeled shelter is more inviting now with an A-frame roof, windows, and wooden bunks. (Courtesy of PATH; photograph by Gordon Burgess.)

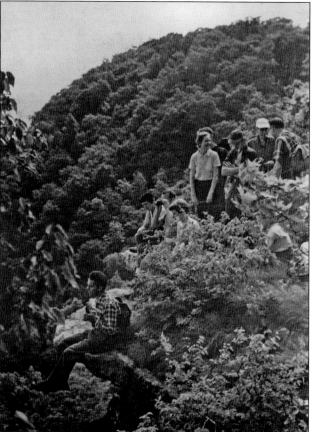

At a viewpoint on Pearis Mountain that overlooks the New River Valley, Earl Shaffer strummed and sang during an outing of Appalachian Trail Conference's 14th biennial meeting in 1958. In addition to being the Appalachian Trail's first thru-hiker, Shaffer was a musician, singer, songwriter, poet, and author. In the upper right are Murray Stevens (left) and Jim Denton; others are unidentified. (Courtesy of RATC.)

Three

CENTRAL VIRGINIA

As in southern Virginia, the AT has been relocated many times in central Virginia. The original route went east of Roanoke where, heading north from Rocky Knob, the trail passed through Sweet Anne Hollow and Slings, Maggotty, Crowell, and Windy Gaps. It then crossed the Roanoke River at Horn's Ford and went into Vinton and Montvale before returning to the crest of the Blue Ridge Mountains.

A relocation that opened in the mid-1930s had the trail swing west of Roanoke by going over Bent Mountain near Adney Gap, running along Poor Mountain, crossing the Roanoke Valley at Glenvar, passing over Fort Lewis Mountain, and following roads in Bradshaw and Mason Cove before coming to Catawba Mountain and what is, more or less, the present route farther north.

All of this changed with the 1955 relocation that, in southern Virginia, brought the Appalachian Trail westward into the Allegheny Mountains. The relocation continued the trail northward into central Virginia by crossing the New River at Pearisburg and going along the Virginia/West Virginia border for a dozen miles.

Heading eastward, the trail goes by what Laurie Messick, on her first thru-hike, dubbed Virginia's "Triple Crown" of viewpoints—Dragon's Tooth, McAfee Knob, and Tinker Cliffs. Re-crossing the Great Valley of Virginia, the trail returns to the Blue Ridge Mountains and turns northward, crisscrossing the Blue Ridge Parkway. The Appalachian Trail was brought back onto its historic route over Apple Orchard Mountain in the 1990s. This is the last time the trail rises above 4,200 feet before reaching New England. Crossing the James River, the Appalachian Trail goes over a series of mountains providing soaring vistas—Bluff Mountain, Cold Mountain, Tar Jacket Ridge, and the Priest. Plunging 3,100 feet into the Tye River Valley, the pathway regains the elevation by ascending Three Ridges to return, once again, to the main crest of the Blue Ridge Mountains, which is followed to Rockfish Gap where the AT enters Shenandoah National Park.

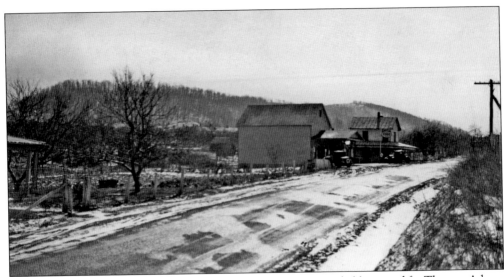

This scene is of Adney Gap on February 19, 1936. The area was probably named for Thomas Adney, who was forcibly put onto a boat in England and dropped off in Charleston, South Carolina, in 1760. Making his way to Franklin County, Virginia, he taught school, surveyed land, and operated a hemp-beating mill. (Courtesy of BRP.)

On February 19, 1936, the Appalachian Trail followed Adney Gap Road for almost a mile from the gap to U.S. 221 at Bent Mountain. This scene is less than a half-mile from the Bent Mountain Post Office where hikers could obtain accommodations after inquiring with the postmaster. (Courtesy of BRP.)

While going across Bent Mountain, Appalachian Trail hikers could take a six-tenths of a mile side trip to Bent Mountain Falls. Located on Camp Branch just above its confluence with Back Creek, the series of cascades that drops close to 700 feet has also been known as Camp Creek Falls and Mannings Falls. (Courtesy of RATC.)

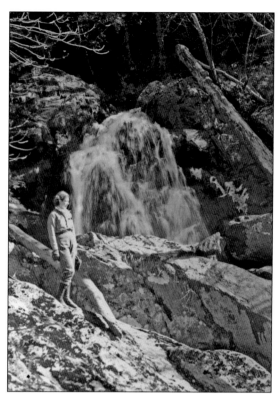

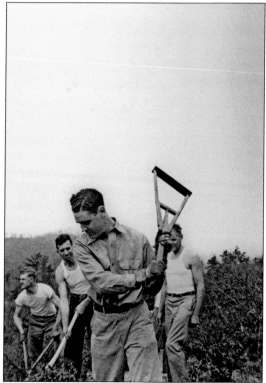

Members of the Roanoke Appalachian Trail Club clear trail on Poor Mountain in September 1940. The implements these men used—weed whip, adze, and clippers—are the same basic tools that volunteer trail maintainers still use today. (Courtesy of RATC.)

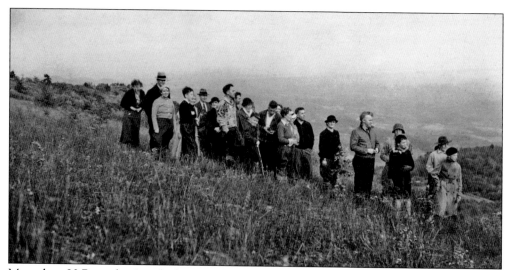

More than 20 Roanoke Appalachian Trail Club members attended a hike on Poor Mountain in 1936. Some sources say the mountain is called poor because of the soil's lack of nutrients. Other references state it was named for Major Poore who, during the French and Indian War, served with Andrew Lewis. Today the Poor Mountain Natural Area Preserve protects the world's largest population of piratebush. (Courtesy of RATC.)

The Appalachian Trail passed through the Hemlock Dell as it descended Poor Mountain. This spot on Dry Branch and a place called "Nature's Own Bathing Beach" on the Roanoke River, which the trail also went by, were so popular that a summer colony grew up around them. (Courtesy of RATC.)

Roanoke Appalachian Trail Club volunteers worked on the Appalachian Trail over Fort Lewis Mountain in 1940. Purchased in 1930 for $2.61 an acre, close to 6,000 acres on the mountain were administered by the Virginia Department of Game and Inland Fisheries as its first management area. After descending the mountain, the Appalachian Trail turned northward and soon connected with what is the present-day route on Catawba Mountain. (Courtesy of RATC.)

In 1958, Earl Shaffer entertained at Shelton's Store in Pearisburg. Shelton, a member of the Roanoke Appalachian Trail Club, could not go on the hike, but the double blaze he placed on the store window led hikers into his establishment for soft drinks and to exchange greetings. (Courtesy of RATC.)

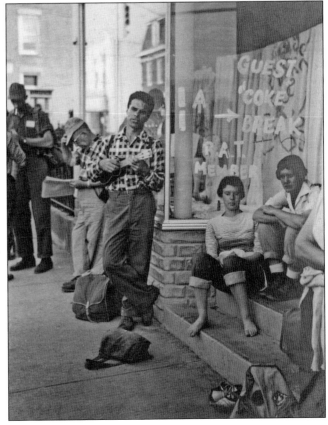

In 1977, Father Charles and the congregation of the Holy Family Catholic Church (above) in Pearisburg opened a hostel (below) for hikers. After Father Charles, and other priests including Father Winter and Father McGhee, continued to welcome weary foot travelers. A Pearisburg native, Bill Gautier, began volunteering to help with the hostel in 1984. Members of the congregation dismantled an old barn and reconstructed it as the hostel on a knoll behind the church. With an outstanding view of Pearis and Peters Mountains, the facility has a kitchen, shower, wood stove, and sleeping loft. After the start of the 21st century, Gautier added a side porch and an entrance roof. (Both photographs courtesy of ATC.)

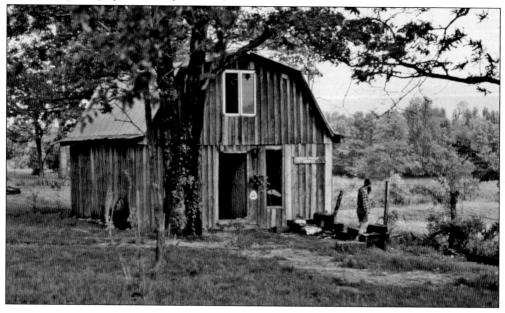

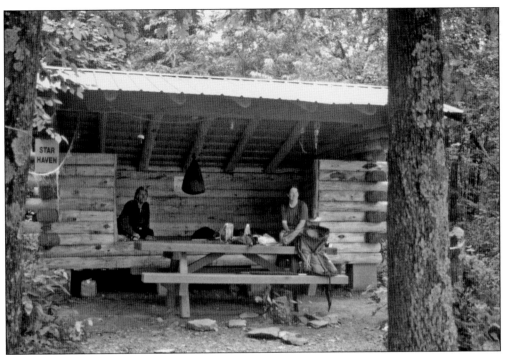

When completed on Peters Mountain in 1995, the Kanawha Trail Club (no longer an Appalachian Trail maintaining organization) dubbed this shelter Star Haven. However, at the time, Jo Ann Starr was the club's trails supervisor, and the forest service, which prohibits naming shelters for living persons, felt "Star Haven" honored Starr. It is simply called Rice Field Shelter in government and Appalachian Trail Conservancy publications. (Courtesy of Leonard M. Adkins.)

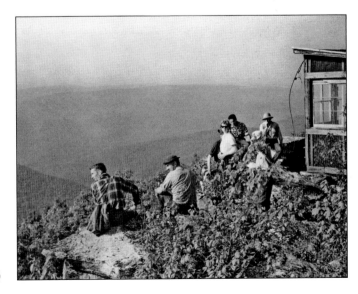

One of the outings for the 14th biennial Appalachian Trail Conference meeting in 1958, held at Mountain Lake Resort less than 5 miles from the trail, was to Wind Rock on the Appalachian Trail. The observation building was dismantled decades ago, but the outcropping still overlooks Stony Creek Valley. (Courtesy of RATC.)

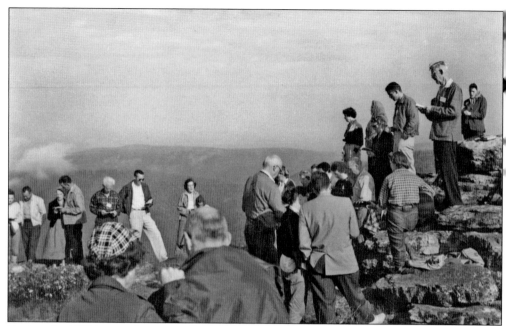

During the 1958 biennial meeting, Rev. Rufus Morgan of Franklin, North Carolina, led sunrise services on 4,365-foot Bald Knob. Pat Cartell of the Georgia Appalachian Trail Club accompanied on guitar. Morgan was on the Appalachian Trail Conference Board of Managers and known as the "one-man trail crew" for his industrious work on the Appalachian Trail in North Carolina. (Courtesy of RATC.)

Camp for the Appalachian Trail Conference's 14th biennial meeting in 1958 was set up on the far reaches of Mountain Lake Resort's golf course at close to 4,200 feet in elevation. Big Mountain (whose ridgeline the Appalachian Trail follows for more than 2 miles) and Butt Mountain are in the background. (Courtesy of RATC.)

From front to back, Molly Denton, Sallie McLain, and Frances Lavern sunbathe during a Roanoke Appalachian Trail Club outing to Mountain Lake Resort in September 1947. Denton and her husband, Jim, were active in Appalachian Trail affairs for many years, and her book, *Wildflowers of the Potomac Appalachians: A Hiker's Guide*, is still in print decades after its first publication. (Courtesy of RATC.)

The Appalachian Trail was located on a dirt road in John's Creek Valley during the 1950s. Salt Pond Mountain, where Mountain Lake Resort and a part of the trail are located, is in the background. Note the white paint blaze on one of the fence posts, denoting that the road is the Appalachian Trail. (Courtesy of RATC.)

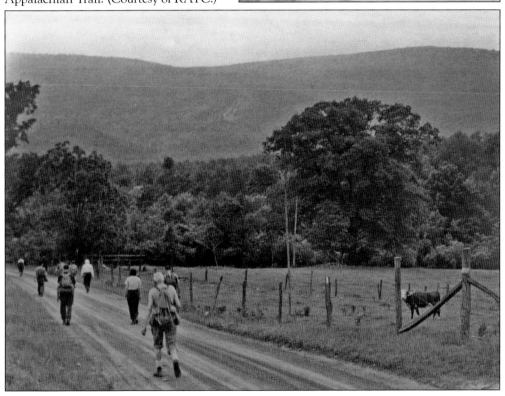

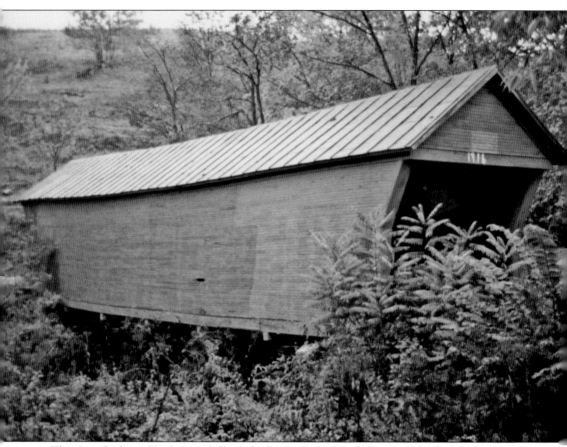

The Appalachian Trail passed through the Sinking Creek Covered Bridge in the late 1970s to early 1980s. Susan Gail Arey spent a stormy, but dry night in the bridge after taking this photograph during her 1976 thru-hike. The modified Queenpost truss bridge with a segmental arch was constructed in 1916 and is 70 feet, 10 inches long and 13 feet, 10 inches wide. It was not dismantled when a new, non-covered bridge was built on VA-603 in 1963. With labor donated by local citizens and volunteers from Virginia Tech, the covered bridge was restored in 2000 and is now painted a bright red and has become a popular tourist attraction. One of the entrance ramps is paved with personalized bricks, a project by the Newport Village Council to help pay for the repairs. The creek's name comes from the fact that its flow diminishes as it continues downstream and disappears completely as it nears the New River. (Courtesy of Susan Gail Arey.)

Jim Denton (right) was one of the volunteers who proposed, scouted, and helped build the Appalachian Trail's largest relocation—the one that brought the pathway into the Allegheny Mountains and to the west of Pearisburg and Roanoke. He was photographed in the 1950s on Dragon's Tooth, one of the places that he and Tom Campbell wanted included into the route. Denton also scouted much of the route of the Big Blue/Tuscarora Trail that was proposed in the 1960s (and later constructed) as an alternate route of the Appalachian Trail through Virginia, West Virginia, Maryland, and Pennsylvania. The photograph below shows that Dragon's Tooth's monolithic formation juts above the treetops. (Above right, courtesy of PATC; below, courtesy of ATC.)

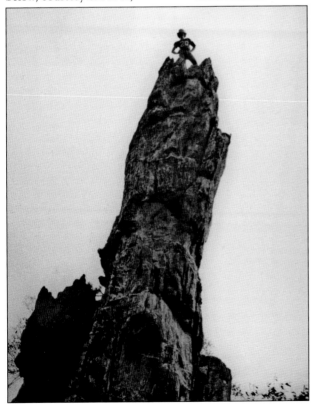

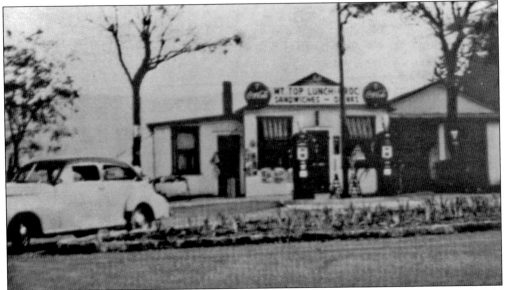

Marks Mundy, Mary Hinkle, and others lived at and operated Mountain Top Lunch beside VA-311 on Catawba Mountain when this photograph was taken in the late 1950s. Patrons sat in six booths on one side or on bar stools on the other while dining on sandwiches, hot dogs, and hamburgers. Purchased by Bunk Sweeny in the mid-1960s, the building was dismantled in the mid-1980s. (Courtesy of Walter Mundy.)

Mountain sandwort is one of Virginia's rare, threatened, or endangered plants that grow within the Appalachian Trail's protected corridor. As evidenced by its species name of *groenlandica*, the plant is more at home in Greenland than it is on Catawba Mountain, where it is close to its natural southern limit. (Courtesy of Joe Cook; Photograph by Joe and Monica Cook.)

Because the trail maintaining clubs were just getting established and many participants were members of several clubs, there was more collaboration between them than there is today. The photograph to the right, from the Myron Avery photograph collection, was taken during a joint outing of the Potomac Appalachian Trail Club, Roanoke Appalachian Trail Club, and Natural Bridge Appalachian Trail Club to McAfee Knob in 1935. The Catawba Valley, below the knob, retains its rural character unto this day. Members of the Roanoke Appalachian Trail Club take a break on McAfee Knob in 1939 (below). Note there was no reservoir as there is today in Carvin's Cove—the bowl of land in the center of the scene. Although the Carvin's Creek Dam was completed in 1928, financial and other problems delayed the completion of the reservoir until 1948. The Peaks of Otter are visible on the far eastern horizon. (Above right, courtesy of ATC; below, courtesy of RATC.)

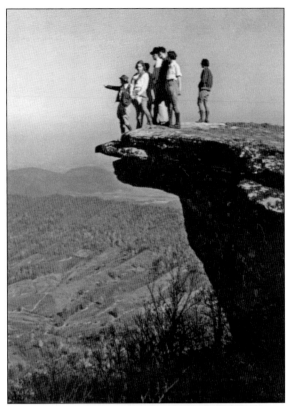

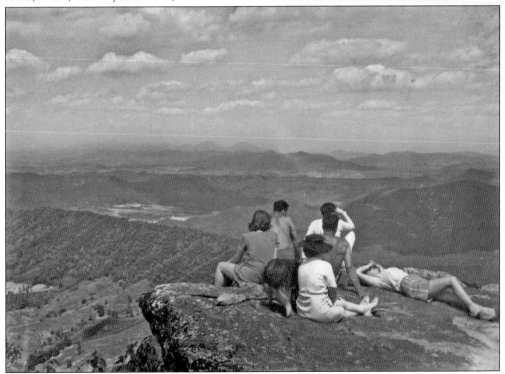

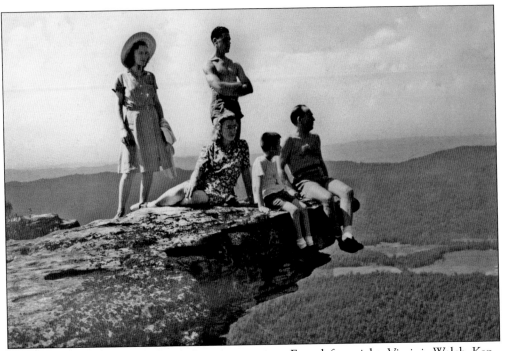

From left to right, Virginia Welch, Ken McCorkindale, Annette Warren, Doug McCorkindale, and Mike Moss enjoy the view from McAfee Knob in 1943. The Appalachian Trail Conservancy believes that the outcrop is the most photographed scene on the entire trail, and many thru-hikers state that it has the best view from the Appalachian Trail in Virginia. (Courtesy of RATC.)

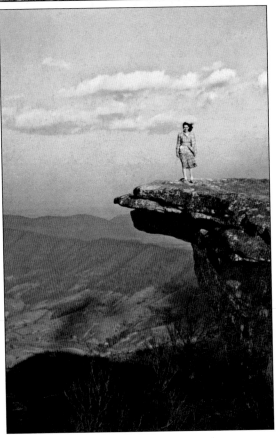

Betty Jo Malloney stands on the Anvil portion of McAfee Knob in 1946. The entire rock ledge is more than one-tenth of a mile long and overlooks not just the Catawba Valley, but also the Roanoke Valley. The knob was actually not on the AT but was reached from the trail by a half-mile walk on a dirt road—drivable well into the mid-1900s. (Courtesy of RATC.)

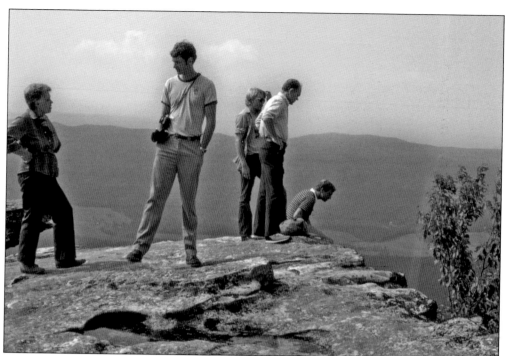

Due to landowner problems, the Appalachian Trail was moved off Catawba Mountain and onto North Mountain, seen in the distance, in 1978. In 1980, (from left to right) Ruth Blackburn, Chris Brown, Mike Dawson, Dave Ritchie, and Les Brower hiked to McAfee Knob to scout out the possibility of returning the trail to the mountain. (Courtesy of ATC; photograph by Rima N. Farmer.)

In the early 1980s, the national park service purchased land on Catawba Mountain, enabling the Appalachian Trail to return. In 1982, Charles Parry and other club members built miles of new pathway, eventually routing the trail directly to McAfee Knob. Parry exemplifies the dedication of Appalachian Trail volunteers, having been the Roanoke Appalachian Trail Club supervisor for more than 30 years and found working on the trail nearly every weekend. (Courtesy of ATC.)

53

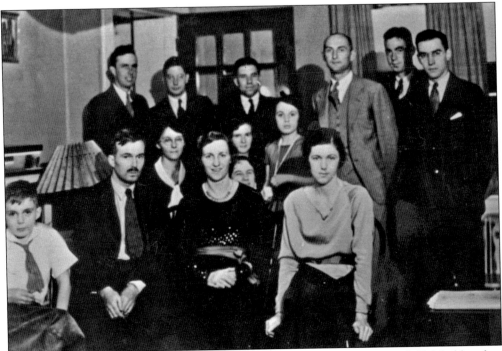

After a hike in the vicinity of Carvin's Cove, the Roanoke Appalachian Trail Club held its first official meeting on November 13, 1932, at the Salem home of Donald S. Gates (seated in the front row), a professor of business administration at Roanoke College. Standing on the far left is David Dick, the club's first trails supervisor. (Courtesy of ATC.)

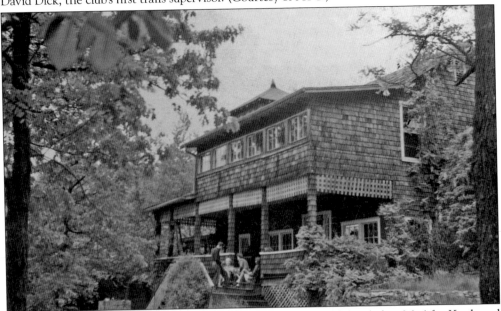

Wild Air was a popular mountain retreat located a few hundred feet below McAfee Knob and was a favorite place for the Roanoke Appalachian Trail Club functions including board meetings, annual gatherings, and relaxed outings, such as this one that took place in summer 1943. The east lawn overlooked the Roanoke Valley. (Courtesy of RATC.)

Activities took place year round at Wild Air and a stone fireplace, with its impressive namesake inscription, was a gathering spot on chilly winter evenings. The facility was burned in the 1980s, and the only reminders of it ever having existed are a few foundation outlines and the still-standing fireplace. (Courtesy of RATC.)

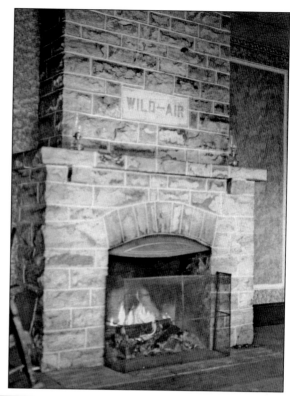

Members of the Roanoke Appalachian Trail Club rest on Tinker Cliffs in 1958. The half-mile long sandstone precipice was created during the Silurian period more that 400 million years ago. Catawba Valley is directly below, with North Mountain, where a portion of the Appalachian Trail was located in the 1970s and 1980s, across the valley. (Courtesy of RATC.)

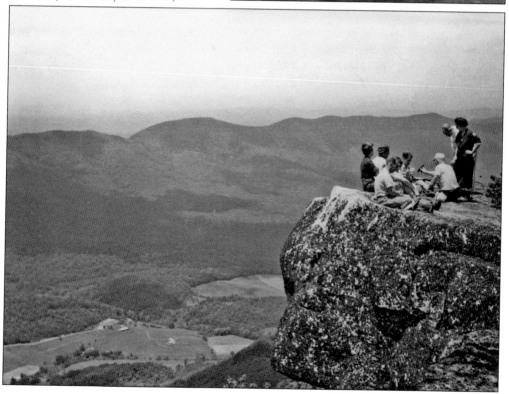

Hikers who currently spend the evening in the deep woods at Lamberts Meadow Shelter often wonder about the name. This photograph of Lamberts Meadow (above), with the north peak of Tinker Mountain visible in the distance, was taken between the 1920s–1930s. Although now heavily forested, the meadow, along with much of the land on Catawba and Tinker Mountains, was under agricultural cultivation well into the mid-1900s. In the same vicinity as Lamberts Meadow, the view that these Roanoke Appalachian Trail Club hikers (below) had in 1939 would no longer be possible because of heavy forest growth. In addition, the agricultural land below them has been under the waters of the Carvin's Cove reservoir since 1948. (Both photographs courtesy of RATC.)

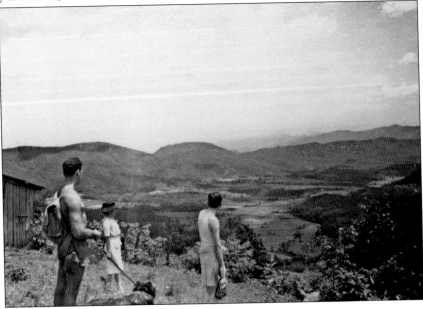

Tom Campbell (above) posed on Tinker Mountain in 1949. Campbell was president of the Roanoke Appalachian Trail Club in the 1950s and personally scouted much of the more than 150-mile relocation that opened in 1955. He named Lost Spectacles Gap, near Dragon's Tooth, after losing his glasses there. He also called a place on Tinker Mountain "Scorched Earth Gap" because, after a steep climb up the side of the mountain, one of his companions "let loose such a string of expletives that she scorched the earth." Campbell's sense of humor was also on display by his choice of a costume during a 1950 Halloween party (below). (Both photographs courtesy of RATC.)

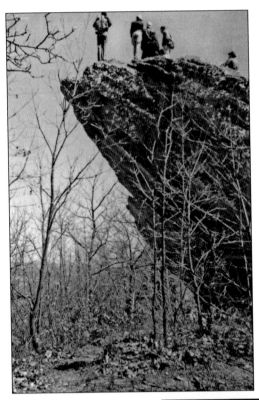

Those who are unafraid of heights, such as this group of 1930s hikers, are rewarded with a grandstand view of Carvin's Cove, McAfee Knob, and the Great Valley of Virginia after scrambling to the top of Hay Rock, another Silurian period sandstone formation on Tinker Mountain. (Courtesy of RATC.)

Carvin's Creek Falls are no longer existent. The 80-foot dam that created Carvin's Cove reservoir was built on top of the falls in 1928. The reservoir flooded what had been a close-knit rural community, and old roads and home foundations become visible when the water level drops during a drought. (Courtesy of RATC.)

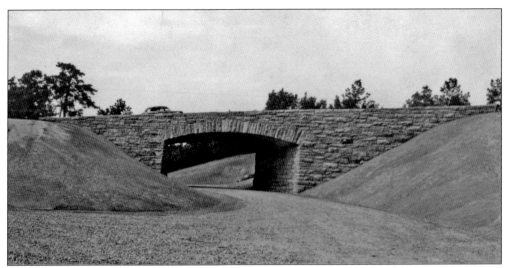

North of Roanoke, the Appalachian Trail returns to the Blue Ridge Mountains and Parkway. The 1934 *Guide to the Paths of the Blue Ridge* provides details about the trail through Bear Wallow Gap. However, the 1941 edition, published just before this August 8, 1941, photograph, merely gives a brief description of a proposed relocation, "The Blue Ridge Parkway is being superimposed on the original Trail route." (Courtesy of BRP.)

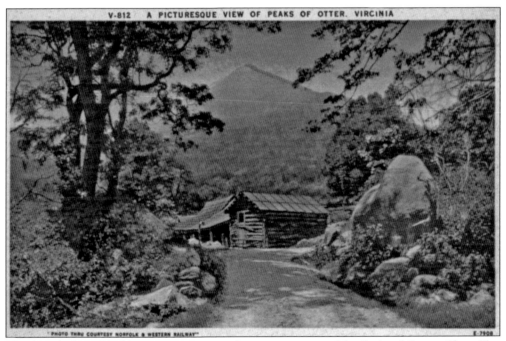

The Appalachian Trail has never gone over the main summits of the Peaks of Otter—Sharp Top and Flat Top. While the present route is located about 5 miles to the west, the original route did pass directly below the two summits. This vintage linen postcard is of Sharp Top taken from the Vaughn Family homestead on the eastern side of the mountain. (Courtesy of Asheville Post Card Company.)

The Peaks of Otter area has beckoned travelers for centuries. Eastern bison used the pass as a way across the mountains, as did Native Americans and early westbound settlers; Thomas Jefferson was one of the first to climb Sharp Top. On April 4, 1963, the park service built an improved trail to the summit. (Courtesy of BRP; photograph by D. C. Ochsner.)

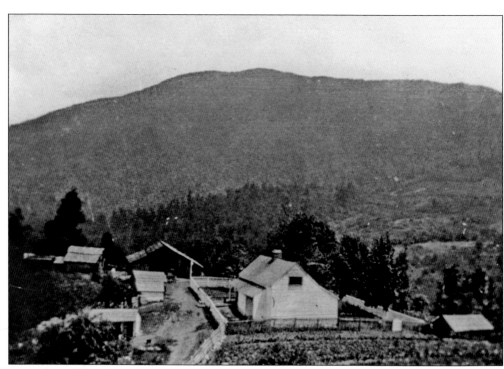

A number of people settled in the Peaks of Otter area, such as the Johnson family on the north side of Harkening Hill. By the 1920s, when this photograph of the Johnson Farm was taken, there was a thriving community with a church and a school. Besides farming, some residents worked at, or sold produce to, Hotel Mons, located just west of the present-day Peaks of Otter Lodge. (Courtesy of BRP.)

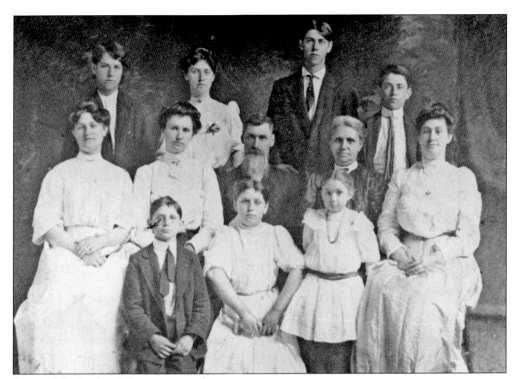

Some of the Peaks of Otter area residents gathered for a photograph around 1930. From left to right are (first row) Bert Vaughn, Nettie Fisher, and Jessie Hogan; (second row) Betty Johnson, Fannie Gross, Joe Vaughn, Mary Watson Vaughn, and Nannie Holdren; (third row) identified only as the Joe Vaughn family. (Courtesy of BRP.)

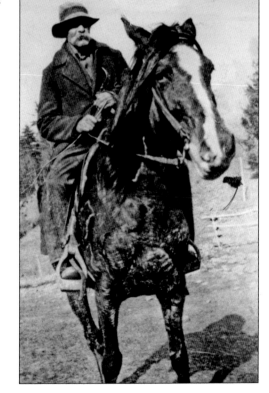

Mack Bryant married Callie Johnson, and the couple took over the operation of the Johnson Farm about 1915. Bryant, pictured on his horse named Lady around 1920, acted as the community's vet, while Johnson supplied cultivated flowers from her garden and wildflowers picked from the mountainsides to the Hotel Mons' dining room. (Courtesy of BRP.)

Located in Wilkinsons Gap (now labeled Wilkerson Gap on Appalachian Trail Conservancy maps), this structure was not built as a trailside shelter, but it certainly had to be a welcomed sight when photographed by Ruskin S. Freer on December 19, 1930. (Courtesy of NBATC.)

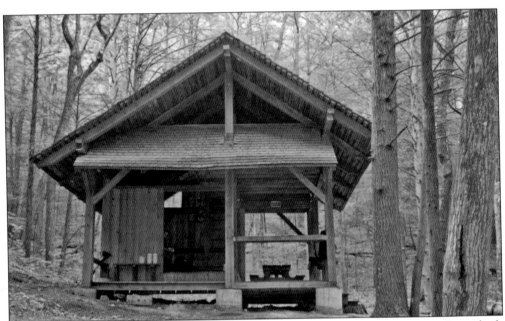

The Bryant Ridge Shelter is one of the Appalachian Trail's most elaborate structures. It was built in 1992 as a collaborative effort by the Appalachian Trail Conference, Natural Bridge Appalachian Trail Club, the forest service, and the Garnett family who supplied funds in memory of Nelson Garnett Jr. The design was selected from submissions by Catholic University architecture students. (Courtesy of ATC.)

The original c. 1920 lookout tower on Apple Orchard Mountain was nothing more than old limbs nailed to a dead tree trunk. Note that there were only two guide lines attached to the top of the trunk—they may have helped stabilize it during high winds but certainly would not have kept it, and anyone who climbed it, from falling to the ground. (Courtesy of RATC.)

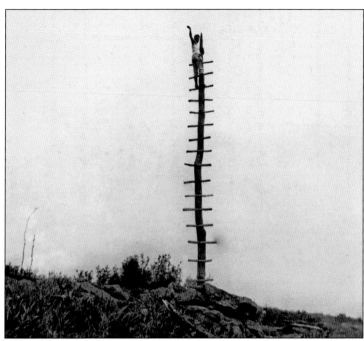

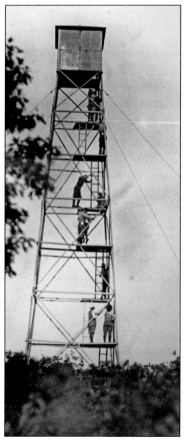

A more stable lookout tower had been constructed on Apple Orchard Mountain by the time of a Potomac Appalachian Trail Club outing in June 1930. For more than 20 years, the Appalachian Trail crossed the summit until the Strategic Air Command operated a radar station from 1954 to 1975. The Federal Aviation Administration currently uses the radar to monitor domestic flights, but efforts by the Natural Bridge Appalachian Trail Club returned the trail to the mountaintop in the 1990s. (Courtesy of ATC.)

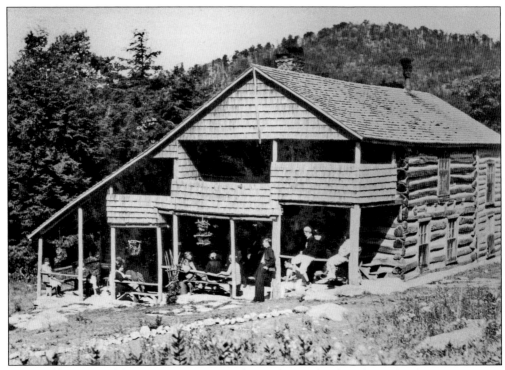

Operated by Gus Welch, Camp Kewanzee on the southern side of Apple Orchard Mountain was a popular summer base for hikers and climbers, as evidenced by a visit from members of the Potomac Appalachian Trail Club in June 1930 (above) and those of the Natural Bridge Appalachian Trail Club (below) in 1937. Welch was a full-blooded Chippewa and was on the Carlisle, Pennsylvania, Indian School football team at the same time as Jim Thorpe. Among his many accomplishments and jobs were his membership on the U.S. Track and Field team for the 1912 Olympics, four years of playing professional football for the Canton Bulldogs, graduation from the Dickinson School of Law in 1917, and position as head football coach for Randolph Macon College. Welch purchased Camp Kewanzee in 1929 and ran it primarily as a youth camp. (Above, courtesy of ATC; below, courtesy of NBATC.)

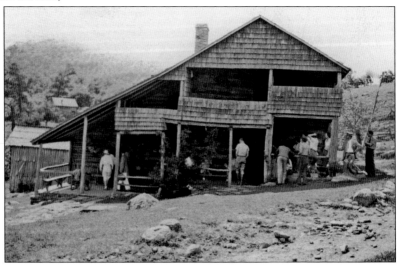

Emma "Grandma" Gatewood, who walked in sneakers and carried her gear in a duffel bag slung over her shoulders, became the first woman to thru-hike the trail alone when she was photographed in 1955. She made history again by eventually becoming the first person to hike the Appalachian Trail's entire length three times. (Courtesy of ATC.)

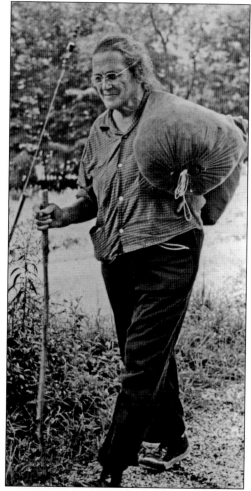

Among the identified members of the Natural Bridge Appalachian Trail Club who built the Marble Springs Shelter in 1933 are the following: (second from left) Elmer Ayres, (third) Charles DeMott, (sixth) Florence Adams, (ninth) Al Willis, and (tenth) Laura Roark. The shelter was destroyed twice—once by a bear and another time by vandals—and members of the club rebuilt it each time. (Courtesy of NBATC.)

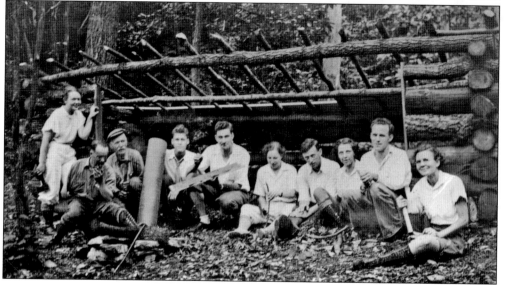

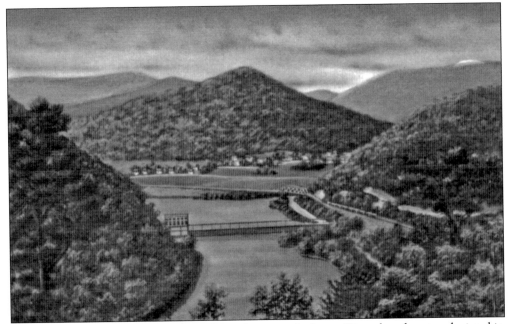

Balcony Falls is upstream from where the trail crosses the James River, but the view depicted in this 1940s linen postcard is accessible by taking a 3-mile side trip from the Appalachian Trail along Sulphur Springs and Balcony Falls trails. (Courtesy of Asheville Post Card Company.)

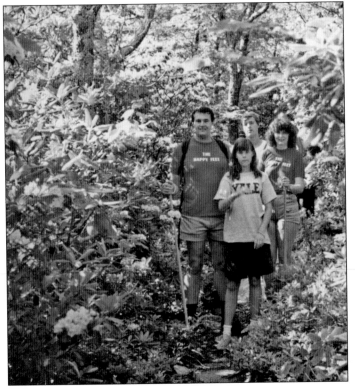

From left to right, Bill, Chrissy, Mick, and Laurie Foot take a hike through rhododendron on June 11, 1989. Known as the Happy Feet during their 1987 thru-hike, Bill and Laurie were the first people to complete the American Discovery Trail, a 6,800-mile route from California to Delaware. In addition, Bill Foot was the driving force behind the construction of the longest foot-use-only bridge on the trail. It crosses the James River on piers that were once a part of an 1800s railroad bridge. (Courtesy of NBATC.)

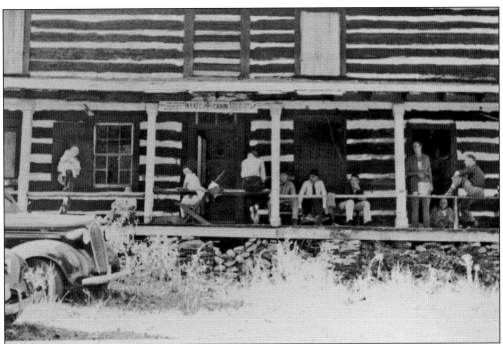

From 1933 to the mid-1940s, the Natural Bridge Appalachian Trail Club rented Camp Sebowisha (above), on Rocky Row Run, from the forest service for $25 a year. The Natural Bridge Appalachian Trail Club was established on October 2, 1930, and was named for the Natural Bridge National Forest (later a part of George Washington National Forest), not the famous geological formation. At an early 1930s club outing in Camp Sebowisha (below) are, from left to right, the following: (first row) Culver Batson (first trails supervisor), Bud Batson, Kelly Batson, Boyd Claytor, Kit Antrim, Marion Baker Clauson, Nella Roberts, and Ruskin Freer (first club president); (second row) Lewis Doggett, Doris Matthews, Florence Adams, Ruth Morris, Peg Payne, Laura Roark, Mrs. Elmer Ayres, and Sue Cross; (third row) Elmer Ayres, Alfred Willis, Eunice Cross, Mary Virginia Coleman, C. L. DeMott (first club vice-president), and Mrs. C. L. DeMott. (Both photographs courtesy of NBATC.)

Not all of the maintaining clubs' activities included planning trail locations and working on the pathway. One of the attractions near Camp Sebowisha was the Blue Hole, a place so popular for swimming that the members of the Roanoke Appalachian Trail Club made a special trip in the late 1930s to enjoy it. (Courtesy of RATC.)

On February 8, 1931, less than five months after the Natural Bridge Appalachian Trail Club was established, members hiked from Robinson's Gap to Whites Gap and Buena Vista. Those who have been identified are the following: (fourth from left) Ruskin Freer, (fifth) Culver Batson, (sixth) Blanche Couesin Hodgkins, (seventh) Elnora Dulaney Hill, (eighth) Richard Bowler, (ninth) ? Hopkins, (tenth) Polly Martin, and (first row center) Lew Brown. (Courtesy of NBTAC.)

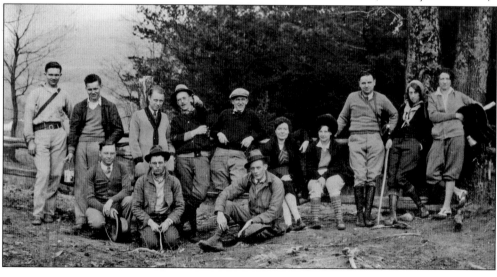

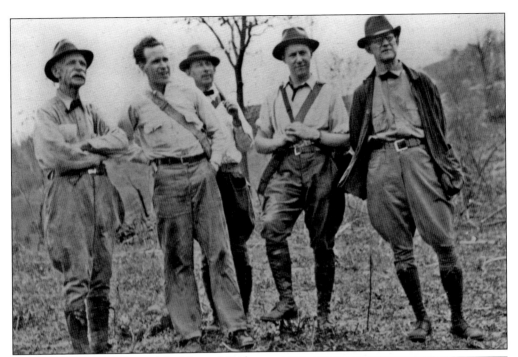

Some of the active hikers of the Natural Bridge Appalachian Trail Club in 1932 were, from left to right, as follows: Charles DeMott, Al Willis, Boyd Claytor, unidentified, and Fred Davis. Jodhpurs, the flared-thigh pants that most of them are wearing, were popular hiking garments of the day. The style originated with equestrians and was soon adopted by the military. (Courtesy of NBATC.)

Members of the Natural Bridge Appalachian Trail Club climbed the Bluff Mountain lookout tower on January 28, 1934. Lookout towers enabled forest service personnel to have a bird's eye view to report a forest fire in its early stages. Thousands of towers were built across the United States, but many were abandoned when airplanes started spotting fires in the 1960s. (Courtesy of NBATC.)

The view from Humphrey's Gap on March 11, 1934, was of U.S. 60 as it descends the Blue Ridge Mountains to Buena Vista. At the time, the Appalachian Trail crossed the highway approximately 4 miles west of where it does today. Buena Vista was only about 2 miles from the road crossing. (Courtesy of NBATC.)

Henry Lanum spent thousands of hours working on the Appalachian Trail, as he was doing in this 1983 photograph. Lanum was the Natural Bridge Appalachian Trail Club president from 1976 to 1978 and trails supervisor from 1978 to 1991, when he died working on trails in Idaho. He created the Pompey Mountain and Mount Pleasant Trails, now known as the Henry Lanum Memorial Trail, accessed from the Appalachian Trail in Hog Camp Gap. (Courtesy of NBATC.)

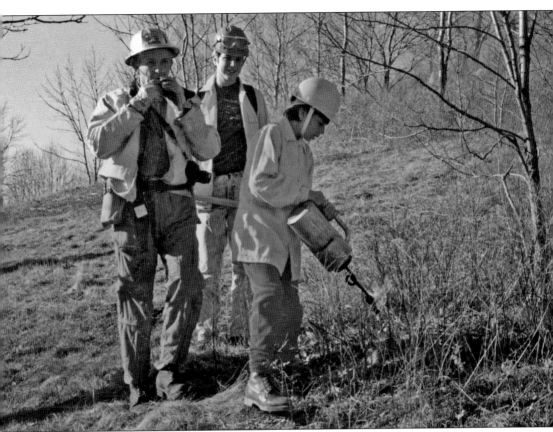

As total public protection and domain over the entire Appalachian Trail came close to being a reality, a small, but significant, controversy arose within the ranks of trail supporters. Open mountaintop vistas are somewhat of a rarity in central Virginia. In bygone days, most of these fields and meadows were kept clear by grazing cattle or other stock. Sometimes the fields were mowed for hay or kept open by controlled burnings. Should these methods, or other human manipulations, be employed, or should nature be allowed to have its way, eventually turning the meadows into forests and blocking the sweeping vistas? A series of discussions among the forest service, maintaining clubs, and ATC led to the conclusion that the rare scenic value of cleared ridgelines outweighed the desire to permit nature to take its course. In March 1990, an unidentified forest service employee and Steve Ripley (middle) looked on as 12-year-old John Ripley set a backfire on Tar Jacket Ridge. Ping-pong balls filled with magnesium, permanganate, and antifreeze were also dropped from a helicopter to aid the controlled burn. (Courtesy of NBATC.)

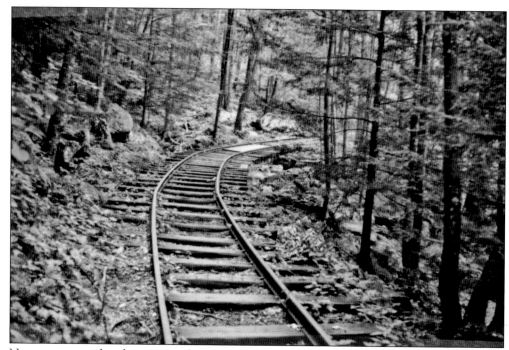

Narrow-gauge railroads penetrated most of Virginia's mountains in the early part of the 20th century, allowing for timber harvesting. The logging was so extensive that the Appalachian Trail in Virginia only passes through a few acres of virgin forest. These tracks at Blue Ridge Parkway milepost 34.4 are a reconstruction and were once accessible via a side trail from a former route of the Appalachian Trail. (Courtesy of BRP.)

From left to right, Hannah Burruss, Sharon Ripley, and Sandra Elder carried a heavy locust log on January 11, 1986, to be used as a waterbar near John's Hollow Shelter, about 2 miles north of the James River. Because of its excellent rot resistance, locust is favored for constructing waterbars, which are used to divert rainwater from the trail and prevent erosion. (Courtesy of NBATC.)

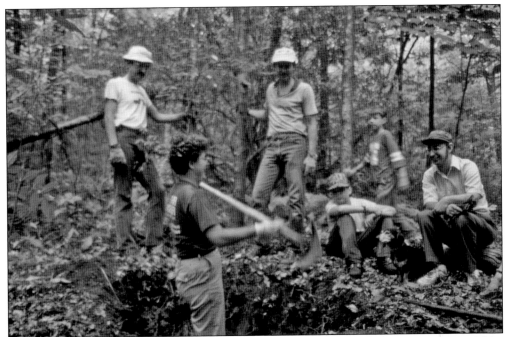

All Appalachian Trail volunteers are considered equals. In this 1986 photograph, a group of able-bodied men looked on as the Natural Bridge Appalachian Trail Club volunteer, Sharon Ripley, took her turn digging the latrine hole for the Cow Camp Gap Shelter. The place is aptly named as cattle once grazed here during the summer before being herded to Amherst later in the year. (Courtesy of NBATC.)

In November 1984, Dave Pinkerton, a member of the Natural Bridge Appalachian Trail Club, carried the outhouse seat to its location during construction of the Seeley-Woodworth Shelter. This shelter is located less than 3 miles south of Spy Rock, a rocky spur of Maintop Mountain that provides a 360-degree view. (Courtesy of NBATC; photograph by Sandra Elder.)

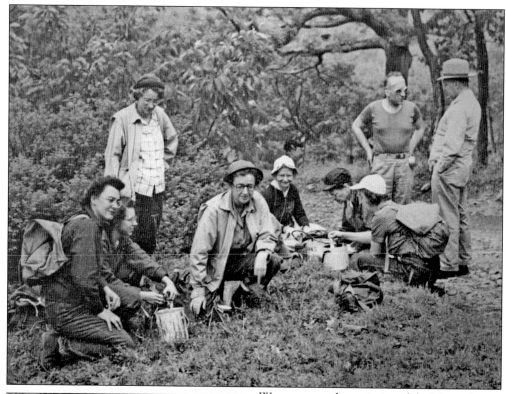

Women were the majority of the Natural Bridge Appalachian Trail Club members in the 1950s and 1960s. Working on a trail relocation over Three Ridges and the Priest in the early 1950s were, from left to right, the following: (NBATC members) Dot (Bliss) Crandall (club president), Esther Leffler, Laura Bliss, and Hester Hastings; (PATC members) Sadie ?, Jean Stephenson, and unidentified; and (standing) Myron Avery and unidentified. (Courtesy of NBATC.)

The Appalachian Trail descends over 3,000 feet to cross the Tye River, named for the early 1700s explorer Allen Tye. The Tye River suspension bridge, photographed here in 1977, was originally built in 1972 and reconstructed by the U.S. Forest Service in 1992. (Courtesy of Susan Gail Arey.)

In August 1969, Hurricane Camille, in combination with another storm front, dropped somewhere between 2 and 3 feet of rain onto the Tye River Valley (right) in less than six hours. The swollen streams—uprooting trees and sending house-sized boulders crashing down the mountainsides—destroyed homes, bridges, and roadways and took a large toll in human life. Enough soil was stripped away to reveal granite rock that had been hidden for hundreds of millions of years. Because the Tye River is located just a few feet from VA-56, its large swimming holes (below) are as popular with locals and automobile travelers as they are with hikers. Standing on the Tye River suspension bridge, Susan Gail Arey documented a family enjoying the water in summer 1978. (Above, photograph by Susan Gail Arey, 1978; below, courtesy of Susan Gail Arey.)

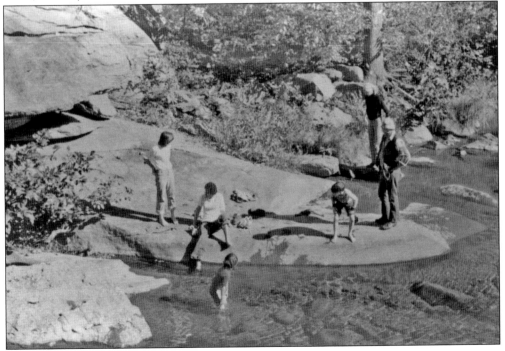

From the Tye River Valley, the Appalachian Trail regains the elevation it lost descending from the Priest. In summer 1977, Mary Ann Barbini made the strenuous 3,000-foot climb to take in the view eastward of Virginia's piedmont from one of the overlooks along Three Ridges. (Courtesy of Susan Gail Arey.)

In 1986, members of the Tidewater Appalachian Trail Club relocated a section of the Mau-Har Trail, a 3-mile side trail that forms a loop with the Appalachian Trail over Three Ridges. Formed in 1972, the club is one of the youngest of the Appalachian Trail maintaining organizations. Besides the Appalachian Trail and Mau-Har Trail, the club also maintains pathways along the Blue Ridge Parkway, in St. Mary's Wilderness, and in Virginia's Tidewater. (Courtesy of Susan Gail Arey.)

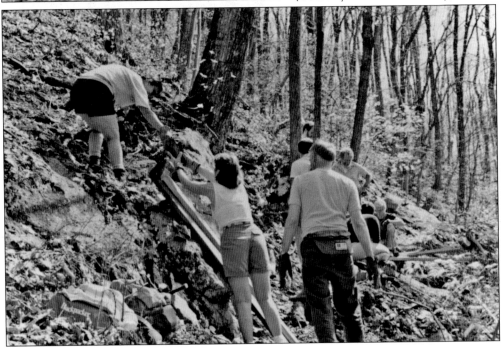

Susan Gail Arey stands in front of the Tidewater Appalachian Trail Club's Douglas Lee Putnam Memorial Cabin. Putnam, an avid hiker, was killed in an accident, and his family donated the money to purchase the land and cabin materials as a permanent memorial. The family stipulated that the cabin be accessed only by a footpath. (Courtesy of Susan Gail Arey.)

On March 17, 1979, Mary Ann Barbini helped prepare the site for the Douglas Lee Putnam Memorial Cabin. The rustic cabin, located near Blue Ridge Parkway milepost 18.3 close to the Tidewater Appalachian Trail Club's section of the Appalachian Trail, is available for rent by club members and their guests. (Courtesy of Susan Gail Arey.)

Marilyn Horrath, who joined the Tidewater Appalachian Trail Club soon after it was formed, led, in conjunction with others, a series of one-week hikes for the club in the 1980s and 1990s that covered the Appalachian Trail from Tennessee to Vermont. She was photographed by Susan Gail Arey in 1995 during a hike on Mount Pleasant, located a short distance from the Appalachian Trail. (Courtesy of Susan Gail Arey.)

Most members of the Tidewater Appalachian Trail Club live close to 150 miles from the section of trail the club maintains, yet there is often a large turnout for work hike weekends. In 2004, at a base camp at Sherando Lake, members decided which tool they wished to use from the ones spread out on the ground. (Courtesy of Susan Gail Arey.)

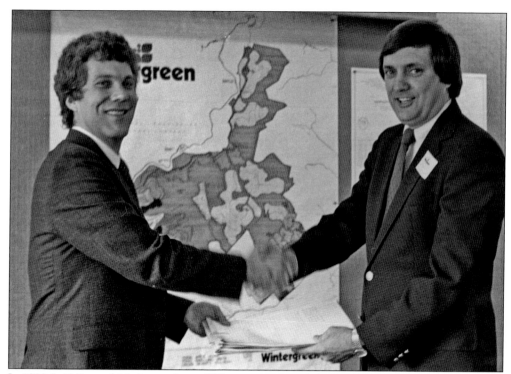

In 1983, L. F. Payne (right), president of Wintergreen, handed over the deed for 2,700 acres of land in the Humpback Rock area to Lawrence Van Meter, Appalachian Trail Conference executive director. This and additional acreage enabled the trail to relocate west of the developing ski resort, now visible from an Appalachian Trail overlook about 4 miles south of Humpback Rocks. (Courtesy of ATC.)

In the mid-1980s, from front to back, ODATC members Jack Williams, Parthena Martin, Jack Kauffman, and Len Cobb worked on the trail relocation around the Wintergreen Ski Resort, providing the Appalachian Trail with several new viewpoints. Martin later moved to North Carolina and became president of the Piedmont Appalachian Trail Hikers. (Courtesy of ODATC.)

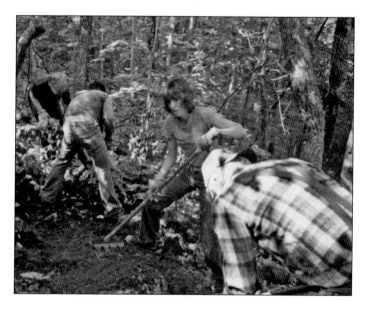

In 1983, Brian Wakeman surveyed the Shenandoah Valley from Cedar Cliffs, an overlook on the Appalachian Trail not far from Dripping Rock on the Blue Ridge Parkway. Wakeman joined the Old Dominion Appalachian Trail Club in 1979 and held programs, trails supervisor, and president positions for the club as well as being on the Appalachian Trail Conference Board of Managers. (Courtesy of ODATC.)

Members of the Old Dominion Appalachian Trail Club take in the view from the mid-1980s Appalachian Trail relocation to the western side of the Blue Ridge Parkway. Below them is the valley created by the flow of Back Creek, while Sherando Lake and Campground are about half way up the Big Levels ridgeline. (Courtesy of ODATC.)

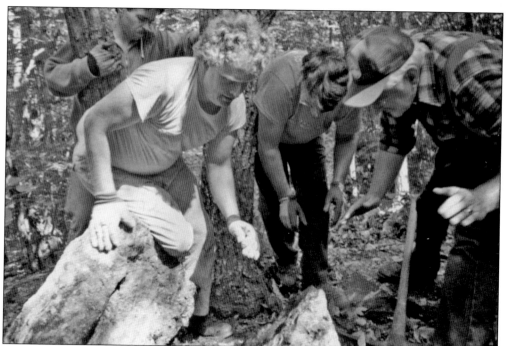

From left to right, Len Cobb, Jack Albright, and Jack Williams contemplated their next move on a particularly rough and rocky section of the trail that was being relocated away from the Wintergreen Ski Resort in the mid-1980s. Jack Kauffman looked on from between the tree trunks. (Courtesy of ODATC.)

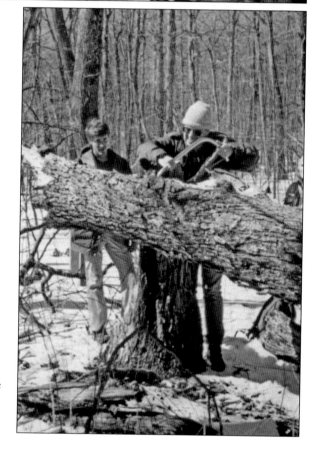

Pat Doyle, a longtime trails supervisor and president for the Old Dominion Appalachian Trail Club, used a bow saw to cut through a branch of a large blowdown during a 1985 cold weather work hike near the Wintergreen Ski Resort. The other person is unidentified. (Courtesy of ODATC; photograph by D. Tyler.)

Jack Williams, who held positions as president and newsletter editor for the Old Dominion Appalachian Trail Club, contributed a series of comics for the club's newsletter, *The Walker*, during the 1980s. The comics were often used as a way to generate volunteer interest at the start of the club's maintenance season. From their very beginnings, all of the Appalachian Trail maintaining clubs have produced a newsletter of some kind, usually on a quarterly basis. The schedules of hikes and social events, reports on past hikes, notices of upcoming work trips, articles about a club's history or exploits of one of its members, and information about issues concerning the entire trail help keep members up-to-date and informed. (Both photographs courtesy of ODATC.)

This scene of Humpback Rocks was taken from Blue Ridge Parkway milepost six in 1946. The meadow, kept open by mowing, was known as Coiner's Deadening. When settlers moved into the mountains, they had to plant crops as quickly as possible, so they girdled the bark of trees, thereby killing ("deadening") the trees and permitting sunlight to reach the garden area. (Courtesy of BRP.)

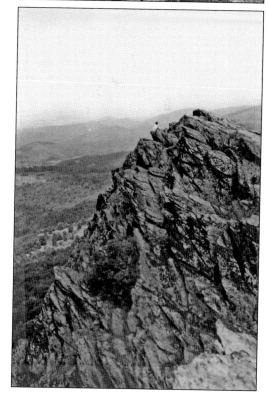

Looking westward, this photograph shows Humpback Rocks on September 2, 1936. The rocks have always been accessed via a side trail from the Appalachian Trail, sometimes as short as 50 feet or as long as three-tenths of a mile. The rocks are volcanic in origin, formed when lava swept over the land millions of years ago. Through time, heat and pressure transformed it into greenstone. (Courtesy of BRP.)

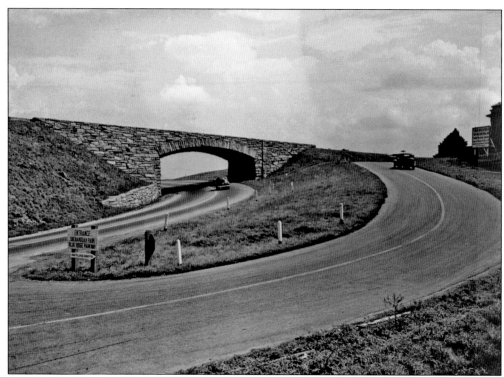

The overpass above U.S. 250 and the entrance road to the Blue Ridge Parkway in Rockfish Gap (above) look much the same today as they did in September 1948. Millions of years ago, the Rockfish River began west of the Blue Ridge and flowed through the gap toward the Atlantic Ocean. At the same time, the Shenandoah River cut through Shenandoah Valley limestone and eventually "captured" the Rockfish River, drying out the gap. The Shenandoah River created other wind gaps, as such places are known, at Manassas, Ashby, Snickers, and Keys Gaps in northern Virginia. The entrance arch (below) to Swannanoa, a palatial home built by millionaire James H. Dooley in 1912, was still standing on July 18, 1949, although the mansion had been vacant for decades. The Howard Johnson restaurant also in this photograph served many hungry hikers until its demise in 1999. (Both photographs courtesy of BRP.)

Four

SHENANDOAH NATIONAL PARK

North of Rockfish Gap, the Appalachian Trail enters Shenandoah National Park, stretching from Rockfish Gap to Front Royal, a distance of almost 75 miles and an area of nearly 200,000 acres. Congress authorized the park in 1926 but provided no funds for land acquisition. The Virginia Assembly appropriated $1 million, and another $1.2 million in donations from various sources, including individual citizens, enabled the purchase of nearly 4,000 tracts of private land.

Some of this land was not sold willingly, and there was (and still is) deep-seated resentment of the government by some of the families who were removed from their ancestral homes. (No reason is given, but the 1935 supplement to the *Guide to Paths in the Blue Ridge* cautions hikers that "until the removal of the mountain people, travel on the local trails is not advised.") While the loss experienced by these people should not be minimized, the natural world certainly benefited. Any signs left behind from lumbering, as well as from grazing and farming, have been largely erased through the resurgence of the forests.

Pres. Franklin Roosevelt dedicated the park in 1936 as men of the Civilian Conservation Corps busily built trails, shelters, fire roads, and visitor facilities. The 105-mile Skyline Drive was completed in 1939. The Appalachian Trail was displaced by Skyline Drive, much like it was with the Blue Ridge Parkway, and now weaves back and forth across it, coming into contact with the roadway more than 40 times. Although it seems this would be an intrusion, the natural beauty of the park still shines through. Ascending from Rockfish Gap, the trail crosses the talus slopes of Blackrock, drops into narrow Ivy Creek valley, and skirts the park's two lodges, Big Meadows and Skyland.

The Appalachian Trail ascends to its highest point in the park (3,837 feet) on the side of Stony Man before going over Mary's Rock, a favorite birders' perch to watch hawks migrate. The trail stays close to 3,000 feet when it crosses Hogback, South Marshall, and North Marshall Mountains before leaving the park near Compton Gap.

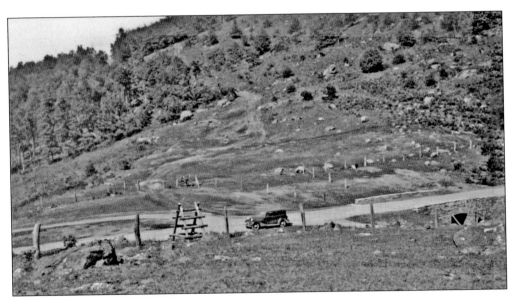

On June 6, 1936, visitors to Shenandoah National Park drive by the fields of McCorkmick Gap (above), through which the Appalachian Trail passes. The hillside meadows have now grown into a mixed forest of evergreen and deciduous trees. Members of the Potomac Appalachian Trail Club do not let a rain shower stop them from taking a hike in Beagle Gap (below) in 1961. At one time, because of topography and private land holdings, it appeared that Beagle Gap would be the southern terminus of Skyline Drive. However, once Pres. Franklin Roosevelt approved the Blue Ridge Parkway project, Skyline Drive planners were able to negotiate an agreement with the landowners that enabled the two scenic highways to meet near Rockfish Gap. (Above, courtesy of BRP; below, courtesy of ATC.)

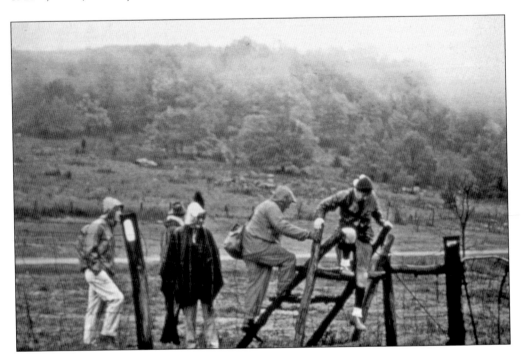

Black Rock Springs Hotel (above) was one of a number of resorts located in the mountains that would become a part of the Shenandoah National Park. The hotel operated from around the 1830s to when it burned in 1909. Visitors came to "take the waters" that emanated from the seven springs touted as cures for a variety of ailments. The hotel site is located about a half-mile to the west of Skyline Drive on the Paine Run Trail, accessed from where the Appalachian Trail comes in contact with Skyline Drive at milepost 87.4. Guests of the hotel often hiked to Blackrock (below). Millions of years ago when erosion exposed this Hampton quartzite, it was already cracked from pressure and cycles of heating and cooling. Rainwater seeping into the fissures froze and cracked the rock further, turning it into the large boulders over which the trail crosses. (Both photographs courtesy of SNP.)

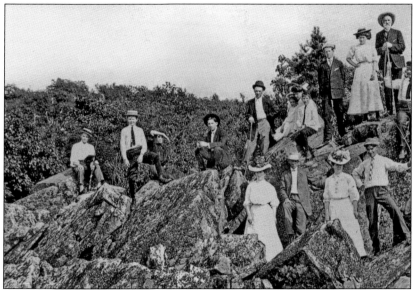

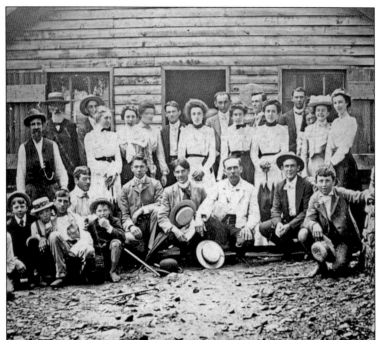

The 1909 fire that destroyed the Black Rock Springs Hotel spared a boarding house nearby. It was subsequently given the same name and operated as such until after the Shenandoah National Park was established. As seen in this photograph, its three-lane bowling alley was popular with the guests. (Courtesy of SNP.)

The Doyles River Shelter was completed by the park service in 1937 (close to when this photograph was taken) on a ledge above the headwaters of the Doyle River. The shelter, located about three-tenths of a mile from the Appalachian Trail, is now operated as a rental cabin by the Potomac Appalachian Trail Club. Approximately a mile below the cabin is the river's upper and lower falls. (Courtesy of SNP.)

Before the establishment of the Shenandoah National Park and the Civilian Conservation Corps, volunteers of the Potomac Appalachian Trail Club had already constructed the Appalachian Trail in most of what would become the park. In 1930, a volunteer (note that he is wearing a tie) conducts a field survey to determine the best route of the trail. (Courtesy of ATC.)

The Civilian Conservation Corps established a number of camps in the Shenandoah National Park, with Camp No. 3 being located on Baldface Mountain. The men of the Civilian Conservation Corps—often referred to as "boys" because, for the most part, they were ages 18–25—constructed a large percentage of the buildings, trails (including the Appalachian Trail), fire roads, and other Shenandoah National Park facilities, many of which are still in use today. (Courtesy of SNP.)

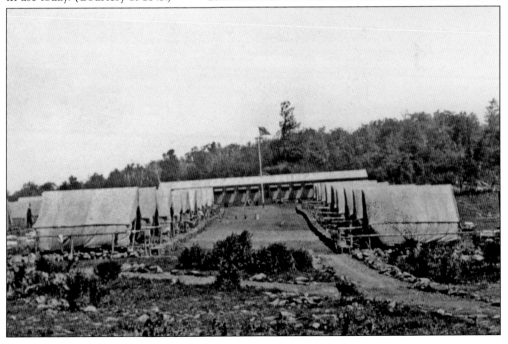

Sometime in 1933 or 1934, one of the Civilian Conservation Corps boys of Camp No. 3, John V. Coxe (left) of nearby Elkton, received a haircut from barber Tony Natolie of Cumberland, Maryland. Each camp was operated as if it were a military base, complete with military discipline and personal hygiene requirements. Years later, Coxe reminisced by looking through his Civilian Conservation Corps scrapbook (below). The book and other memorabilia from Coxe's Civilian Conservation Corps days were deposited on February 25, 1998, by the Harrisonburg-Rockingham Country Historical Society in the special collections section of James Madison University's Carrier Library in Harrisonburg, Virginia. (Both photographs courtesy of ATC.)

Winters during the 1930s in the Civilian Conservation Corps Camp No. 3 got cold and snowy. The camps operated year-round, which is why one of the first projects after a camp was established was to replace the canvas tents with more substantial, and weather resistant, wooden barracks. (Courtesy of SNP.)

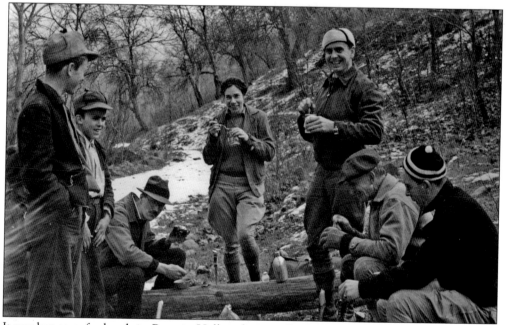

It was hot soup for lunch in Pocosin Hollow during a Potomac Appalachian Trail Club outing on January 16, 1938. From left to right are two unidentified young men, Alvin Peterson, Ann McKener, Bill Sterns, Charlie Thomas, and Howard Olmsted. (Courtesy of PATC, Excursion 27-39; photograph by Howard Olmsted.)

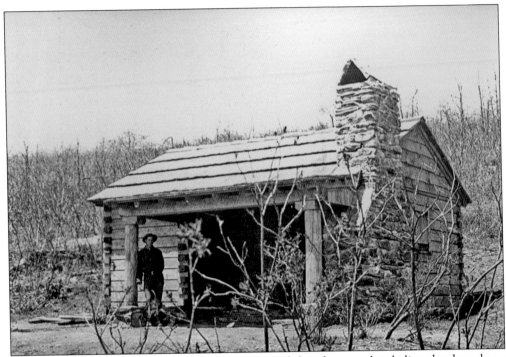

The park service built the Pocosin Cabin in 1937, and this photograph is believed to have been taken shortly thereafter. The cabin is located less than one-tenth of a mile from the Appalachian Trail, several miles south of Bearfence Mountain, and is one of the park's locked cabins operated by the Potomac Appalachian Trail Club on a rental basis. Local lore says the name comes from a Native American word for swamp, marsh, or land subject to flooding. (Courtesy of SNP.)

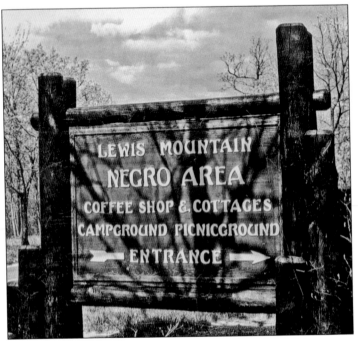

As early as 1932, the park service was formulating a policy of having "provisions for colored guests." Lewis Mountain Campground, opened in 1939, helped enforce the "separate, but equal" policy. Although the campground and Panorama's main dining room were integrated in 1947, it wasn't until 1957 that all of the park's facilities were no longer segregated. The Appalachian Trail skirts the campground, providing showers and refreshments for grimy and hungry hikers. (Courtesy of SNP.)

Formed by the confluence of Laurel and Mill prongs, which the Appalachian Trail runs close to in Milam Gap, the Rapidan River (right) is shown in this linen postcard. With high rag content, the postcards cost less to produce than predecessors and used bright dyes for the image coloring. After being elected president in 1928, Herbert Hoover searched for the perfect weekend retreat. It had to be within a day's drive of Washington, D.C., and above 2,500 feet to be an escape from heat and as free of mosquitoes as possible. Rapidan Camp (below) next to the Rapidan River met all of these requirements, and President Hoover, declining federal or state funds, purchased the land and building materials himself. He and his wife, Lou, sat on the camp's porch to enjoy the cool mountain air. (Above right, courtesy of Marken and Biefield, Inc.; below, courtesy of SNP.)

Being an ardent angler, President Hoover made sure that Rapidan Camp was located close to good trout streams. In this photograph, he is trying his luck in the Rapidan River with a fly-fishing rod and reel. At the end of his term, he donated the camp to the federal government, but future presidents made use of Camp David in Maryland. (Courtesy of SNP.)

Herbert Hoover came to Rapidan Camp to escape the rigors of the presidency, but he also used the retreat to meet with government officials and foreign dignitaries. Visitors often socialized while enjoying beverages in the camp's sitting room. Appalachian Trail hikers can take a side trail of about 2 miles to see the still-standing buildings of the camp. (Courtesy of SNP.)

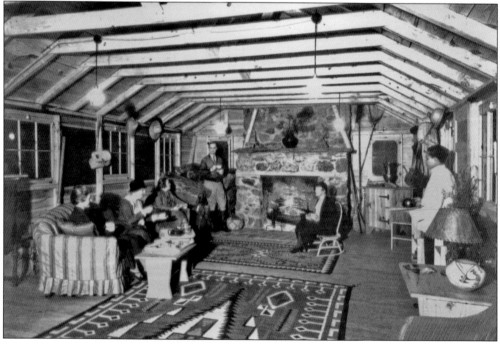

Shortly after his presidential term ended in 1933, Pres. Herbert Hoover had a schoolhouse built for the children who lived close to Rapidan Camp. Photographer Ernest L. Crandall took this photograph of the school located a few miles east of the Appalachian Trail in Fishers Gap. (Courtesy of ATC; from the Myron Avery photograph collection.)

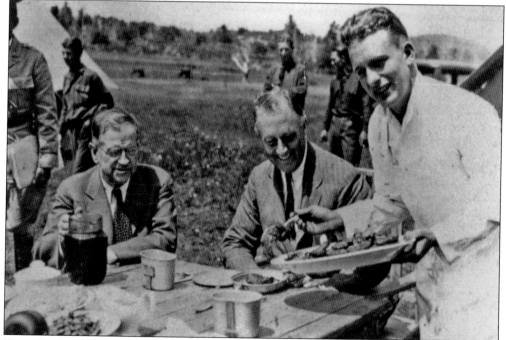

To see firsthand how the Civilian Conservation Corps work was progressing, and to observe camp life, Pres. Franklin Roosevelt visited the Shenandoah National Park in August 1933, when he and other dignitaries were served a meal in one of the camps. (Courtesy of SNP.)

The chestnut blight, a disease accidentally introduced from Asia, removed chestnut trees from the landscape by the end of the 1930s. The chestnut was important in the life of Appalachian residents. The plentiful nuts provided a cash crop, fodder for livestock, and a supplement to people's diet. Homes and fences were built from the durable wood and the tannin-rich bark was sold to process hides. This photograph of the "ghost forest" south of Big Meadows (above) was taken just before the Civilian Conservation Corps began work on the Appalachian Trail in the area. The same scene (below) shows that, during construction of the Appalachian Trail, the Civilian Conservation Corps removed the dead chestnut trees, and the wood was used to build many of Shenandoah National Park's facilities, including Big Meadows Lodge. The trail runs along the lower right in the photograph. (Both photographs courtesy of SNP.)

Although they were not officially members of the Civilian Conservation Corps, mules did the important job of hauling away rocks during the construction of the Appalachian Trail and Skyline Drive. Mules were used as draft animals because they eat less, have fewer hoof problems, and can endure heat better than horses. (Courtesy of ATC.)

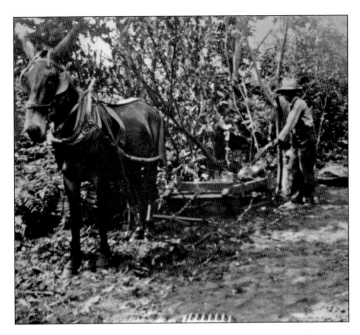

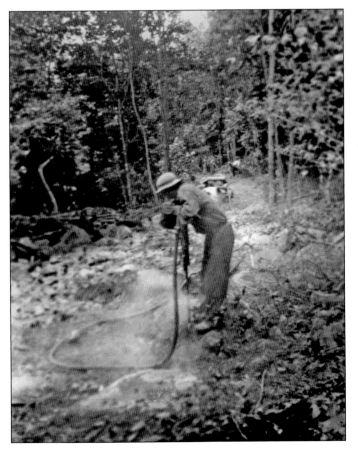

Most of the work was done by hand but, in some places during 1933, employees of the Civilian Conservation Corps used pneumatic drills in the construction of the Appalachian Trail in Shenandoah National Park. A pneumatic drill uses compressed air, usually generated by a portable diesel engine. (Courtesy of ATC.)

97

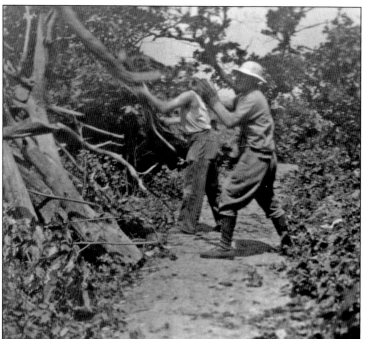

The labor of the Civilian Conservation Corps boys was physically hard. In return, enrollees lived in the camps, where they were provided clothing and meals and were paid $30 a month, $25 of which was sent to their families back home. Because so many young men were enrolled and had an income, historians believe the Civilian Conservation Corps was responsible for a 55 percent drop in crime. (Courtesy of ATC.)

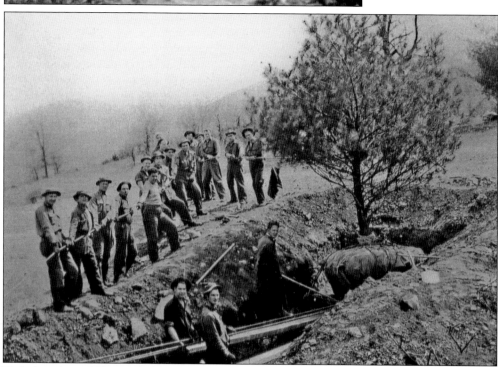

Today's park would be much different if not for the Civilian Conservation Corps boys. Almost all disturbed areas were landscaped with trees, shrubs, and other plants. Some came from nurseries within the park or were obtained from commercial nurseries, while others—such as this full-grown tree—were strategically transplanted from alternate areas in the park to create a pleasing landscape. (Courtesy of SNP.)

At the Big Meadows Civilian Conservation Corps camp in the 1930s (above), a stockade was constructed around the buildings to protect them from damage due to high winds and great snow drifts. Thousands of people listened to Pres. Franklin Roosevelt dedicate the Shenandoah National Park in Big Meadows on July 3, 1936 (below). The ceremony was considered such a major event that it was broadcast live nationwide on NBC and CBS radio. The president said, "We seek to pass on to our children a richer land and a stronger nation. I now take great pleasure in dedicating Shenandoah National Park—in dedicating it to this and to succeeding generations of Americans for the recreation and re-creation which we find here." (Both photographs courtesy of SNP.)

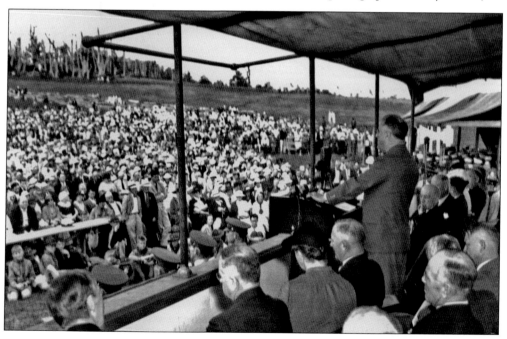

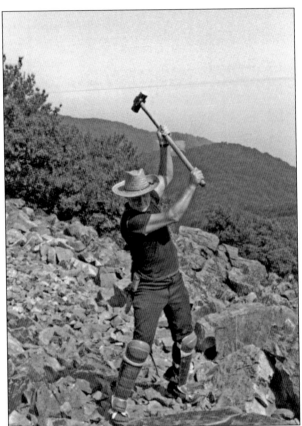

Dean Simms breaks rock along a portion of the Appalachian Trail to smooth out the footpath in the Shenandoah National Park, continuing the work that the Civilian Conservation Corps boys did in the 1930s and 1940s. Along the length of the trail, it is estimated that volunteers provide so much free labor that it is valued at well over $3 million annually. (Courtesy of ATC.)

The deer population in the southern Appalachians was nearly decimated by human consumption and loss of habitat by the start of the 20th century. To rectify this, herds were imported from the North and released into the mountains by the national park service, private clubs, state game agencies, and individual citizens. Sightings are now common, such as this deer photographed in Big Meadows. (Courtesy of SNP.)

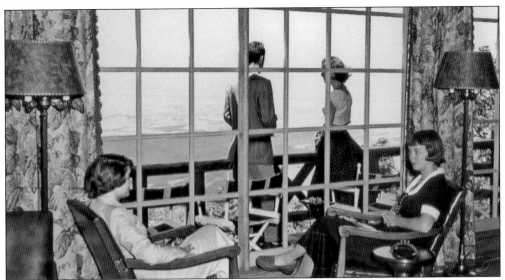

Within its first official year, Shenandoah National Park received more than one million visitors. The Virginia Sky-Line Company was contracted to build and operate Big Meadows Lodge to provide overnight accommodations. Constructed of native materials, including chestnut timber, the lodge opened in 1939. A 1950s publicity photograph shows visitors enjoying the view from the porch and "comfortable sitting area." (Courtesy of SNP.)

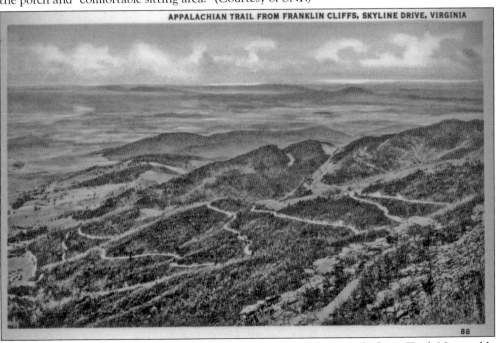

This *c.* 1930s postcard is one of the most rare concerning the Appalachian Trail. Not visible in the photograph, the trail runs along a shelf on the cliffs. The postcard's caption, "Over the winding slopes of the Blue Ridge, the Appalachian Trail offers unusual thrills and glorious scenery to the hiker and horseman," is incorrect. The trail was never open to equestrians who were, and still are, permitted on the Red Gate Fire Road, the prominent switchbacks seen on the hillside. (Courtesy of Marken and Biefield, Inc.)

The timber rattlesnake (shown here) and the copperhead are the only two poisonous snakes to inhabit Appalachian Trail lands. Timber rattlesnakes have heavy bodies that typically have dark blotches in the front that fuse to form crossbands in the back. Their color ranges from yellow to pinkish-gray to black, but the tail is almost always black. These identifying features may fade as the snake matures. (Courtesy of SNP.)

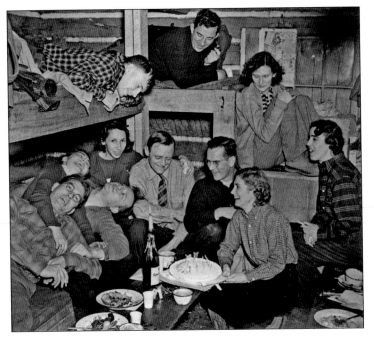

The date of this gathering of friends in Rock Spring Cabin is unknown, though most of National Park Service photographer Abbie Rowe's pictures were taken from the 1940s to the 1960s. The caption reads, "It may be impolite to lie down after eating at home, but in the shelter system it is unwritten that you can if you want to—and the party did." (Courtesy of ATC.)

Members of the Potomac Appalachian Trail Club accompany Myron Avery as he uses, what would become, his famous measuring wheel to determine the distance of a spur trail to the summit of Hawksbill. At an elevation of 4,050 feet, the mountaintop is the highest point in the Shenandoah National Park. (Courtesy of SNP.)

The Appalachian Trail passes under the cliffs of Crescent Rock, a prominent feature in the central section of the Shenandoah National Park. Religious revivals were held on the rock before the establishment of the park. Like Franklin Cliffs, the peak was created after layers of lava flowed across the landscape millions of years ago. (Courtesy of Marken and Biefield, Inc.)

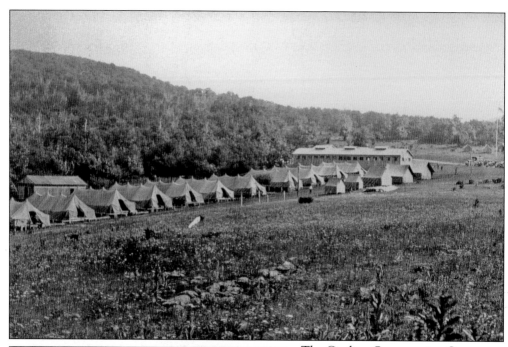

The Civilian Conservation Corps camp near Skyland, located on the east side of Skyline Drive south of the Timber Hollow Overlook, was known as Camp George H. Dern. This photograph was taken soon after the camp was established in 1933. The frame mess hall and washroom/privy were unusual for a Civilian Conservation Corps camp, as the corps began using prefabricated buildings within the next year. (Courtesy of SNP.)

Hemlock forests, such as those once found on the Limberlost and Passmaquoddy Trails, located short distances from the Appalachian Trail, have become increasingly rare due to the hemlock woolly adelgid. First appearing in America in the 1920s, these insects had a minimal effect on western hemlocks, but by the 1950s, more susceptible eastern hemlock trees began to weaken. More than 90 percent of the park's hemlocks have died as a result. (Courtesy of SNP.)

George Freeman Pollock came to the mountains on a scientific expedition to study mammals for the Smithsonian Institution and observe copper-mining operations—of which his father owned part interest—on Stony Man Mountain. A colorful and tireless promoter, Pollock opened his mountain resort, Skyland, in 1894, and a carriage road from Luray wound up the western slope of the Blue Ridge, carrying guests to the lodge. (Courtesy of SNP.)

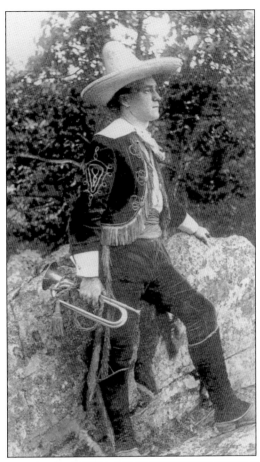

The Albertype Company of Brooklyn, New York, was founded in the 1890s and used a technological innovation, known as collotype, to photomechanically reproduce images. One of the postcards it created shows Skyland in 1930. More than 50 bungalows catered to flatlanders, politicians, and business leaders who found it to be a congenial place to enjoy the mountains and escape the heat of summer. (Courtesy of Albertype Company.)

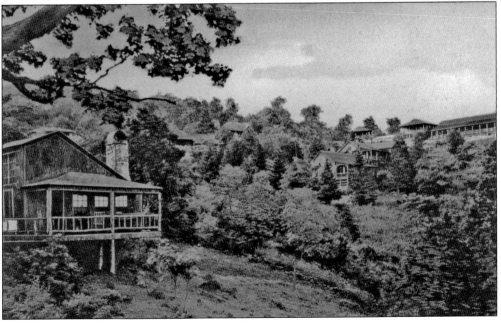

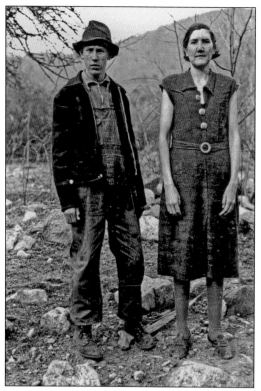

More than 460 people lived in the hollows and hillsides located between Skyland and Old Rag Mountain when the Shenandoah National Park was established in the 1930s. Austin and Mrs. Woody Corbin (shown left) lived in the upper part of Nicholson Hollow. Years before the establishment of the park, George Freeman Pollock said Aaron Nicholson and his relatives declared the hollow to be a "free state" and not subject to the laws and taxes of Virginia. Historians disagree if this is true, but the 1934 *Guide to the Paths of the Blue Ridge* makes reference to "Free State Hollow." Charles "Buck" Corbin (below) lived near the road that went over Robertson Mountain from the Old Rag Post Office in Weakley Hollow to Skyland, a distance of about 5 miles. (Both photographs courtesy of SNP.)

Around 1930, park ranger Gibbs (right) visited William Erastus "Rast" Nicholson (left) and his son Robert in Nicholson Hollow (above). William Nicholson was born in 1873 and passed away on July 31, 1952. Robert Nicholson was born June 9, 1920, and died on October 15, 2006, after working 40 years for the Virginia Department of Transportation. When the family's homestead of 37 acres was condemned for the Shenandoah National Park in the mid-1930s, the land was valued at $615. George W. and Lucy E. Hurt (right) were 2 of the 78 people still living in the park in 1940. In that year, George was 79 and his wife was 77. He passed away in March 1942, and she died one month later at the home of their daughter and son-in-law who lived outside the park. (Both photographs courtesy of SNP.)

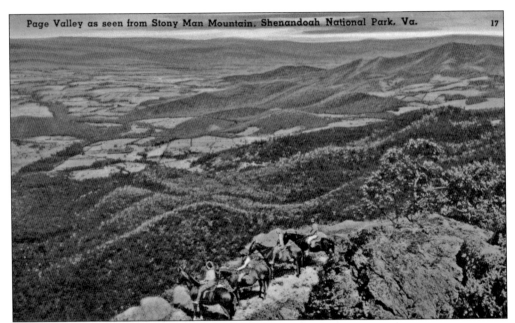

At one time, the Appalachian Trail went below Stony Man Mountain's summit on the Passamaquaddy Trail, built under the direction of George Freeman Pollock in 1932. The Appalachian Trail now runs along the mountain's eastern edge, providing access to the summit via a short side trail. (Courtesy of Shenandoah News Agency.)

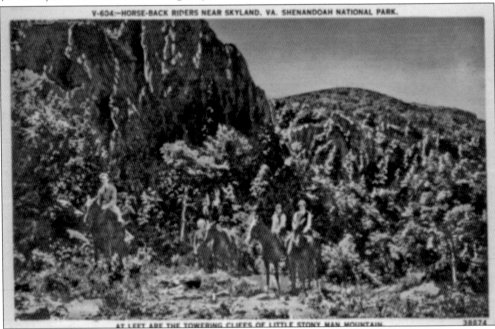

Not everything on a postcard should be trusted. The inscription on the back of this linen postcard of Stony Man Mountain states, "At the summit of the highest mountain in the state of Virginia, and in the most picturesque portion of the Blue Ridge on the famous Skyline Drive, is located Skyland, just nine miles east of the town of Luray." However, Mount Rogers in southern Virginia is the state's highest point. (Courtesy of Asheville Postcard Company.)

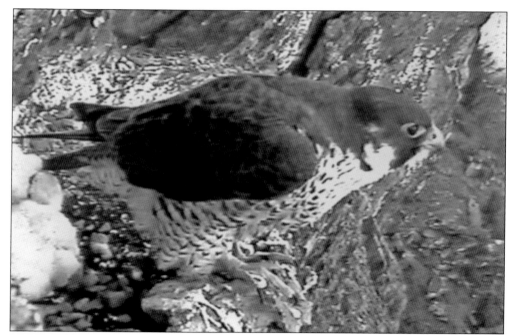

Peregrine falcons fell victim to the insecticide DDT. The poison caused some hatchlings to be born deformed or weakened the eggshells, which broke before the chicks were ready to be hatched. After DDT was banned in the 1970s, falcons were bred in captivity and released into the wild. The program has proved successful, as evidenced by this female and her chicks photographed on Stony Man Mountain. (Courtesy of SNP.)

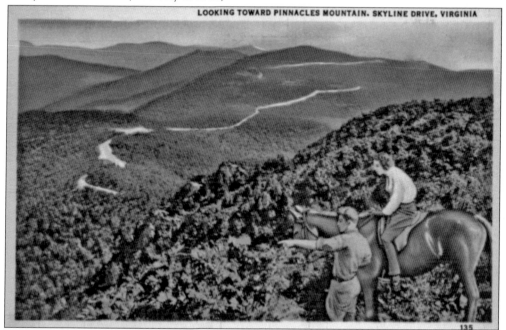

LOOKING TOWARD PINNACLES MOUNTAIN, SKYLINE DRIVE, VIRGINIA

The Appalachian Trail passes just a few feet to the right of the highest point on the Pinnacle, 3,730 feet above sea level. This linen postcard was mailed with a 1¢ stamp from Luray on October 17, 1945, to Mr. Paul Sechrist. (Courtesy of Marken and Biefield, Inc.)

The Sexton Shelter (above), dedicated on September 8, 1930, was named for Dr. Roy Lyman Sexton, who contributed to the total construction cost of $930.57. The shelter was located west of the present Pinnacles Picnic Grounds, which the Appalachian Trail passes through. The Potomac Appalachian Trail Club records appear to indicate it was the first shelter to be built by the club on land that would become the Shenandoah National Park, and it became the prototype for shelters later constructed by the Civilian Conservation Corps. The fence was constructed to keep out livestock grazing in the adjacent meadow. The endangered Shenandoah salamander (below) is found only on north or northwest slopes of the Pinnacle, Hawksbill Mountain, and Stony Man Mountain within the Shenandoah National Park. Its survival is not guaranteed, but living within the park provides a level of protection. (Both photographs courtesy of SNP; bottom photograph by Leonard Via.)

Dorothy Walker and Mary Rose were doing some housecleaning at the Meadow Spring Shelter that, according to the Potomac Appalachian Trail Club's 1941 *Guide to Paths in the Blue Ridge,* was built in 1930 by club members H. C. Anderson and Dr. J. F. Shairer. It was located three-tenths of a mile east of the Appalachian Trail on the Buck Hollow Trail. (Courtesy of PATC.)

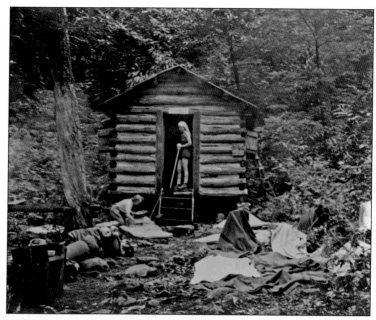

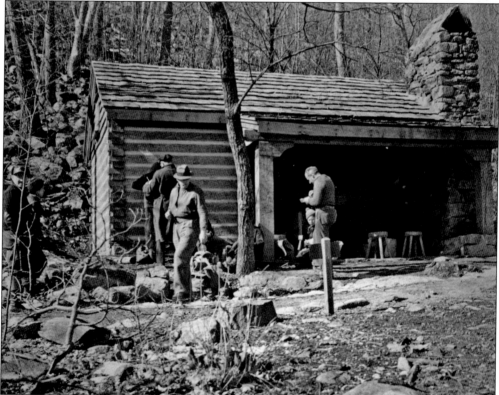

The original Meadow Spring Shelter was replaced with a squared chestnut log building in 1939 and was equipped with blankets, mattresses, cooking utensils, first aid kits, lanterns, brooms, and other items. Kerosene, soap, and matches were replenished as needed. The shelter was destroyed by fire in November 1946. (Courtesy of ATC; photograph by Charles Pryor.)

The Civilian Conservation Corps faced a formidable task when working on the trail leading to the summit of Mary's Rock. Note the worker in the lower left and how small he is in relation to the huge rocks and boulders that are in the path of the planned route. (Courtesy of SNP.)

The same scene a few months later shows the trail building skills of the Civilian Conservation Corps boys. The boulders have been removed and the pathway, ascending at a gentle grade, is reinforced with rock cribbing. The Appalachian Trail still makes use of this route, which has required very little maintenance. (Courtesy of SNP.)

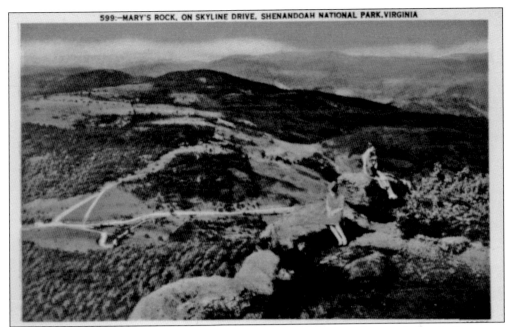

A 360-degree view is obtained at Mary's Rock by scrambling to the top: below is Panorama Crossroads, with Pass Mountain, Three Sisters Knobs, and Neighbor Mountain; northward are the Hogback Mountains; eastward is the Little Devils Stairs gorge between Little Hogback and Mount Marshall; the Piedmont is visible beyond Oventop and Jenkins Mountains; southward are the Pinnacle and Stony Man Mountain; and westward is Massanutten Mountain. (Courtesy of Asheville Postcard Company.)

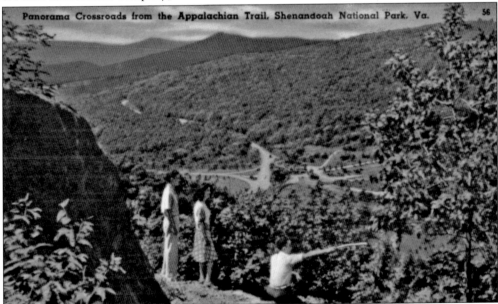

Panorama Crossroads from the Appalachian Trail, Shenandoah National Park, Va. 56

The Appalachian Trail, as it descends northward from Mary's Rock, overlooks the Panorama Crossroads. At the time this postcard was published, between the 1930s and 1940s, Panorama offered a restaurant, overnight accommodations, snack bar, gift shop, and gasoline station. The structure is now a service building for the park service. (Courtesy of Shenandoah News Agency.)

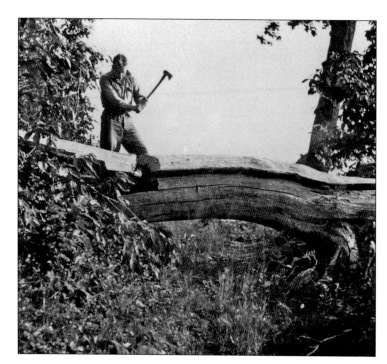

Myron Avery had to clear a chestnut tree that fell across the Appalachian Trail in June 1929, just three months after the trail had been built in Gravel Springs Gap. Avery was elected as the Potomac Appalachian Trail Club's first president at the club's opening meeting on November 22, 1927. (Courtesy of ATC; photograph by A. Ellis.)

Twenty-five miles of the Appalachian Trail are visible in this photograph taken by ? Hepburn in 1930. In the center is Mount Marshall, named for the noted chief justice of the U.S. Supreme Court, whose extensive estates included the mountain. (Courtesy of George Freeman Pollock; from the Myron Avery photograph collection, ATC.)

Five

NORTHERN VIRGINIA

Two years after the establishment of the Appalachian Trail Conference in 1925, some members of the Wildflower Preservation Society, based in Washington, D.C., formed the Potomac Appalachian Trail Club. Within five years, club volunteers had built more than 250 miles of the Appalachian Trail, extending it from Rockfish Gap to the Susquehanna River in central Pennsylvania. This feat is all the more remarkable considering there were very few roads that permitted access to the mountains and tools common to trail work today, such as chainsaws and ratchet loppers, did not exist. Much of the work was done with small hand axes and pruning shears. There was also a scarcity of federal and state land, so much of the Appalachian Trail had to go through private property, with trail advocates having to obtain the owners' permissions. In numerous ways, the Potomac Appalachian Trail Club is the grandfather of the other trail-maintaining clubs in Virginia, as many of its members provided assistance and expertise to help those clubs become organized.

North of the Shenandoah National Park, the Appalachian Trail follows an easement on land belonging to the National Zoological Park, crossing Manassas Gap, and passing through an area ablaze with trillium in the spring. North of Ashby Gap, the trail, until the 1980s, followed a paved roadway through a development of suburban homes (with fence lines plastered with No Trespassing signs) for more than 10 miles. Hikers often complain about the seemingly senseless frequent ups and downs of this trail relocation, but the narrow corridor through which the Appalachian Trail passes is now in public hands and free from threats of development.

Once the trail passes through Snickers Gap, it is only a minor variation in elevation at Keys Gap that brings the Appalachian Trail to a descent to leave Virginia by crossing the Shenandoah River and arrive in Harpers Ferry, West Virginia, home of the Appalachian Trail Conservancy.

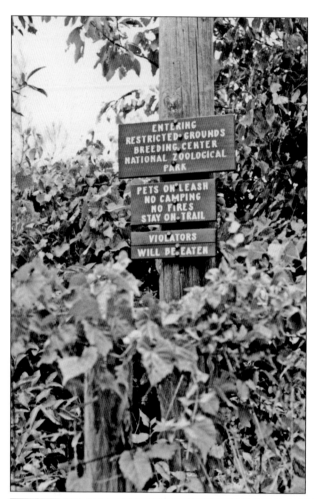

A few miles north of the Shenandoah National Park, the Appalachian Trail crosses over property belonging to the National Zoological Park's Research and Conservation Center. Before this, it was a U.S. Department of Agriculture research station; an earlier use was as a U.S. Cavalry remount post. Since at least 1976 (when this photograph was taken), this sign has greeted hikers to the property. (Courtesy of Susan Gail Arey.)

The Mosby Lean-to, seen in this 1940 photograph, serviced hikers from the 1930s to 1980, when it was believed to be stolen for its chestnut logs. The shelter received its name because members of Colonel Mosby's raiders are thought to have lived nearby during and after the Civil War. (Courtesy of ATC; from the Myron Avery photograph collection.)

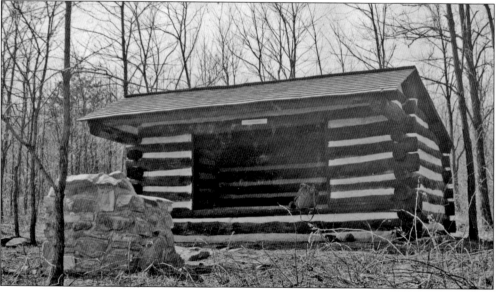

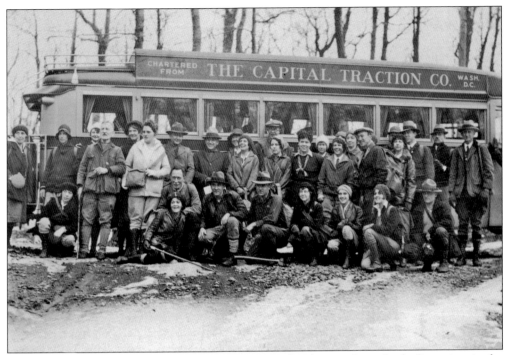

The Appalachian Trail became popular almost immediately upon being built. Sometime in the 1920s, a group of hikers arrived from Washington, D.C., via chartered transportation to begin their outing near Bluemont. This photograph is from the collection of Kathryne Fulkerson, general secretary of the Potomac Appalachian Trail Club in the 1930s. (Courtesy of ATC.)

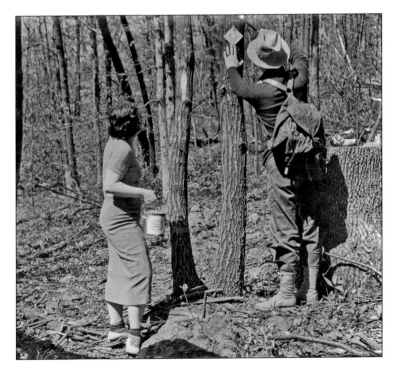

Abbie Rowe wrote of the Potomac Appalachian Trail Club work hike he photographed in the 1930s, "All work on the trail is voluntary. Work trips are made by chartered bus with a lead and organized groups. Many trips are made by private car with small groups as shown here where metal markers are being replaced and old blazes repainted." (Courtesy of PATC.)

Not all of the work that goes into maintaining the Appalachian Trail takes place in the woods. Here Mary Jo Williams (right), *PATC Bulletin* editor, works on some club correspondence as Leola Stoll looks on. Williams joined the Potomac Appalachian Trail Club in December 1929 and was a member of the club's first trail crew, known as the "Dirty Dozen." (Courtesy of PATC.)

It was not all hard labor when the Potomac Appalachian Trail Club did go into the woods. In 1938, Joe Winn (left) and Bob Beach provided the evening entertainment. Winn joined the club in 1932 and was the programs chairman for many years. Beach joined the club in 1933, and the two played together for close to 50 years, sometimes for the square dances the club sponsored for several decades. (Courtesy of PATC.)

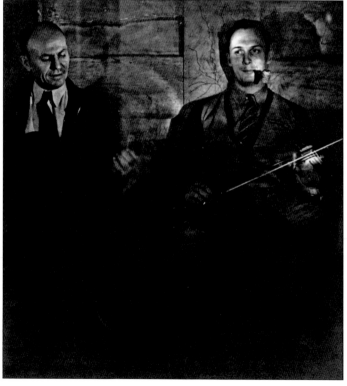

For more than a decade, Thomas Culverwell provided some comic relief in the early editions of the *PATC Bulletin* with humorous drawings depicting the joys and trials and tribulations of hiking and working on the trail. His 1964 *Map of the Stony Man Region in Shenandoah National Park, showing the Skyline Drive and man's pursuits & pleasures in this region from the most ancient times down to the present* has become a collector's item. Culverwell was also a rock climber and cave explorer and a member of the Speleological Society of the District of Columbia. In 2006, the National Speleological Society published his artwork from that endeavor as *The Cave Art of Tom Culverwell.* (Courtesy of PATC.)

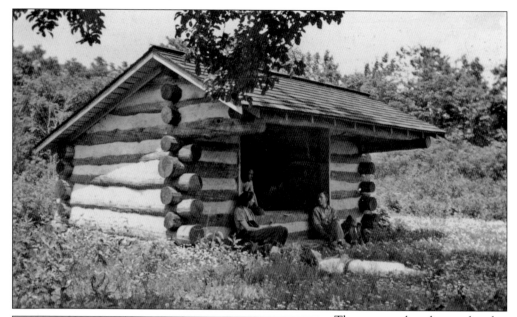

There was only a dirt road and a few small homes in the area where Three Springs Lean-to was built in 1940. By the time the trail was relocated in the 1980s, fashionable homes lined the entire route of what had become the two-lane, paved VA-601, and the lean-to existed within the last remaining bit of woods on the ridgeline. (Courtesy of ATC.)

Dr. Jean Stephenson was the volunteer founding editor of the Appalachian Trail Conference's *Appalachian Trailway News* when it was established in 1939, paying for the publication of its first two issues with her own money. Stephenson also served as a secretary for Myron Avery, who often kept her up until midnight dictating letters. She is seen here taking field notes in 1942. (Courtesy of PATC.)

In the winter of 1946–1947, a group of hikers (right) took a bus from Washington, D.C., to begin a hike at Snickers Gap where the Appalachian Trail crosses VA-7 near Bluemont. They returned home via the B&O Railroad once they reached Harpers Ferry. Sabra (Baker) Staley, wearing a white headband on the right of the middle row, sent this photograph to the Appalachian Trail Conference in 1991. In an accompanying letter, she stated that she could not recall the names of the other hikers, but that "the tow-headed youngster and his sister (in the upper left) were young teenagers (13? 14? 15?), but I remember them as capable and good sports." Two of the hikers (below) who accompanied Staley on the winter 1946–1947 hike were photographed with their winter clothing. Staley said, "Our gear was all Army surplus backpacks from World War II or Boy Scout packs." (Both photographs courtesy of ATC.)

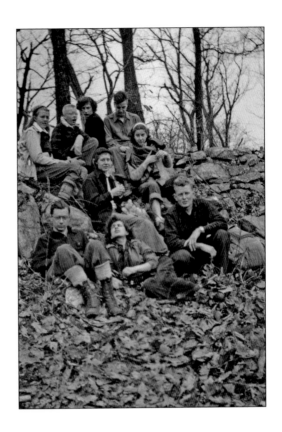

Ray Fadner, with weed whip in hand in this 1979 photograph, continued the volunteer work of early Potomac Appalachian Trail Club members by being the club's 14th president and a trails supervisor for a dozen years. He joined the club in 1948 and participated in club activities to within a few years of his death in 1996 at the age of 79. (Courtesy of PATC.)

An increase in automobile traffic and home construction on VA-601 led trail supporters to relocate the Appalachian Trail in the 1980s. Because it goes over a series of side ridges and in and out of numerous hollows, this section of trail is often referred to as the "Appalachian Trail roller coaster." To accommodate hikers overnight, the Rod Hollow Shelter, shown here being constructed by Potomac Appalachian Trail Club volunteers, was dedicated in September 1985. (Courtesy of PATC.)

Local stonemasons built Bear's Den (above) in the 1930s as the summer home of Dr. Huron Lawson and his wife, opera singer Francesca Kaspar. The large common room was constructed to have excellent acoustics because it served as a recital room for Kaspar. As part of the lands purchased to relocate the Appalachian Trail off VA-601 in the 1980s, the lodge, owned by the Appalachian Trail Conservancy and managed by the Potomac Appalachian Trail Club, is a trail and environmental education center as well as a hikers' hostel. Less than a five-minute walk from Bear's Den Trail Center, Bear's Den Scenic Rock Overlook (below) provides a soaring view of the Shenandoah Valley, as seen in this photograph from 1986. The view was always there but only became available to Appalachian Trail hikers after the trail was relocated from VA-601. (Both photographs courtesy of ATC.)

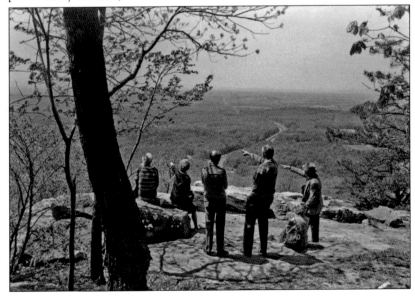

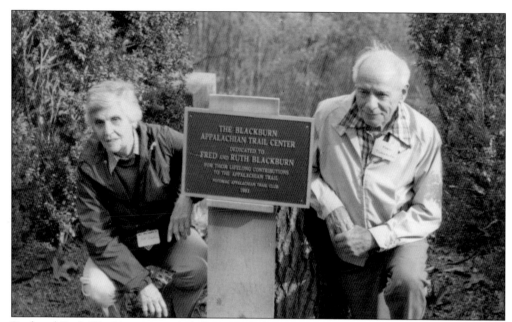

Fred and Ruth Blackburn attended the 1981 dedication of the Blackburn Trail Center, named to honor their years of service to the Appalachian Trail, other eastern trails, the Appalachian Trail Conference, and the Potomac Appalachian Trail Club. Fred Blackburn was president of the Potomac Appalachian Trail Club from 1951 to 1954 and a proponent of the Tuscarora Trail through Virginia, West Virginia, Maryland, and Pennsylvania. Ruth Blackburn was the Potomac Appalachian Trail Club president from 1965 to 1967 and the Appalachian Trail Conference chairperson in the early 1980s. (Courtesy of PATC.)

The Blackburn Trail Center, pictured here in 1981, was originally the retreat of Dr. William Folwer of Washington, D.C. Purchased by the Potomac Appalachian Trail Club in 1979, the center is accessed from the Appalachian Trail via a side trail and serves as a place for club activities, a gathering spot for trail maintenance work hikes, and a place where Appalachian Trail hikers may stop to rest, obtain water, or spend the night. (Courtesy of PATC; photograph by Cathy Miller.)

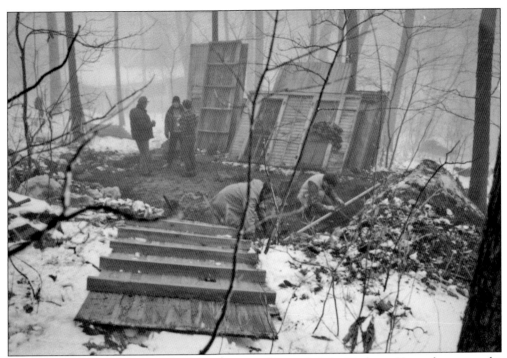

The Potomac Appalachian Trail Club volunteers dismantled the Hudgens House from a nearby property and reconstructed it at the Blackburn Trail Center during winter 1986–1987. Originally serving as a workshop for the Blackburn Trail Center, the Hudgens House is now an overnight cabin for Appalachian Trail hikers, complete with a wood-burning stove to keep visitors warm during cold winter evenings. (Courtesy of PATC; photograph by Cathy Miller.)

In 1968 in Washington, D.C., Pres. Lyndon Johnson (standing in the center) signed the National Scenic Trails Act, which designated the Appalachian Trail and the Pacific Crest Trail as America's first two national scenic trails. Small amounts of money were appropriated to help purchase land for each pathway. (Courtesy of ATC; photograph by Jack Rottier.)

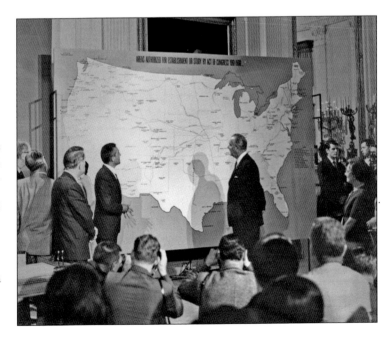

Ed Garvey, photographed during his 1970 journey, was one of the first people to thru-hike the Appalachian Trail after it was designated a national scenic trail. His memoir, *Appalachian Hiker*, was published in 1971 and is credited with bringing about a nationwide awareness of the Appalachian Trail. Hundreds, and possibly thousands, of people were inspired to try a thru-hike after reading the book. (Courtesy of ATC.)

In 1990, on the 20th anniversary of his thru-hike, Ed Garvey attempted a second such trek at the age of 75, as shown in this photograph. Although he only completed about half of the trail, he wrote *The New Appalachian Trail*, full of observations on the hike and how the Appalachian Trail had changed through the years. Garvey passed away in 1999. (Courtesy of ATC.)

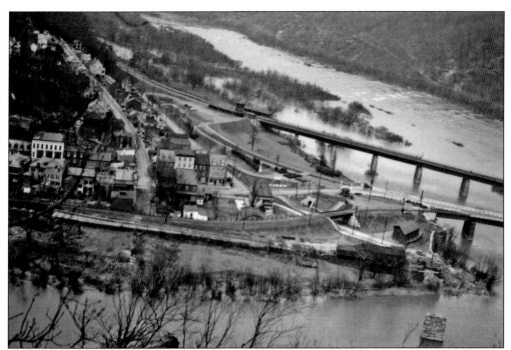

The first section of the Appalachian Trail to be constructed by the Potomac Appalachian Trail Club was located within Loudon Heights. That portion of the trail, with a view of Harpers Ferry, West Virginia (where little has changed since this *c.* 1946 photograph), is no longer on the Appalachian Trail but may be reached by a side trail. The Appalachian Trail was rerouted into Harpers Ferry, where the Appalachian Trail Conservancy is headquartered, in the 1980s. (Courtesy of ATC.)

Benton MacKaye, the man whose efforts not only bore fruit on the Appalachian Trail but who also helped shape the way Americans view their responsibilities toward the wilderness, was photographed a short time before he passed away on December 11, 1975, at the age of 96. In his words, "The ultimate purpose of the Appalachian Trail? To walk. To see. And to see what you see." (Courtesy of ATC.)

DISCOVER THOUSANDS OF LOCAL HISTORY BOOKS FEATURING MILLIONS OF VINTAGE IMAGES

Arcadia Publishing, the leading local history publisher in the United States, is committed to making history accessible and meaningful through publishing books that celebrate and preserve the heritage of America's people and places.

Find more books like this at
www.arcadiapublishing.com

Search for your hometown history, your old stomping grounds, and even your favorite sports team.

Consistent with our mission to preserve history on a local level, this book was printed in South Carolina on American-made paper and manufactured entirely in the United States. Products carrying the accredited Forest Stewardship Council (FSC) label are printed on 100 percent FSC-certified paper.

MADE IN THE USA

Made in the USA
San Bernardino, CA
20 May 2020

71963914R00256